HAUNTED
AUBURN _{AND}
OPELIKA

HAUNTED AUBURN AND OPELIKA

FAITH SERAFIN, MICHELLE SMITH + JOHN MARK POE

Haunted America

Published by Haunted America

A Division of The History Press

Charleston, SC 29403

www.historypress.net

Images and illustrations by Faith Serafin.

First published 2011

Manufactured in the United States

ISBN 978.1.60949.230.4

Library of Congress Cataloging-in-Publication Data

Serafin, Faith.
Haunted Auburn and Opelika / Faith Serafin, Michelle Smith, and John Mark Poe.
p. cm.
Includes bibliographical references.
ISBN 978-1-60949-230-4
1. Ghosts--Alabama--Auburn. 2. Ghosts--Alabama--Opelika. 3. Haunted places--Alabama--Auburn. 4. Haunted places--Alabama--Opelika. 5. Historic sites--Alabama--Auburn. 6. Historic sites--Alabama--Opelika. 7. Auburn (Ala.)--Social life and customs--Anecdotes. 8. Opelika (Ala.)--Social life and customs--Anecdotes. I. Smith, Michelle. II. Poe, John Mark. III. Title.
BF1472.U6S47 2011
133.109761'55--dc23
2011021476

To my grandparents, Al and Velma Huguley.
The greatest storytellers of all time.

CONTENTS

Acknowledgements 9
Introduction 11

The Legend of Springvilla Mansion 13
The Highwayman 19
The Love of Charlotte 23
Apartment 12 30
Der Häftling Geist 34
The Shadow Man at Villa Bar 41
The T.K. Davis Justice Center 45
The Moonshiner's Ghost 48
Salem Shotwell Bridge in Opelika Municipal Park 54
Sydney Grimlett: The Most Famous Ghost on the Plains 59
Samford Hall 63
Pine Hill Cemetery 66
The Pinetucket House and Mary Elizabeth's Ghost 69
Robert Trent Jones and the Ghost of Mary Dowdell 72
The Legend of Chewacla 74
The Legendary Confederate Camp Watts 78
The Auburn Train Depot 82
The Ghostly Frontiersman 84
The Altar in the Woods 92
The Ghost of Tandy Key 96

CONTENTS

The Brewington House 101
The Little Girl in the Window 105
The Devil's Mouth at Moffitt's Mill 111
The Headless Ghost of Highway 80 115
The Huguley Homes 117

Bibliography 123
About the Authors 125

ACKNOWLEDGEMENTS

We'd first like to thank our friends and families who supported us in our endeavor of writing this book, as well as members of the Alabama Paranormal Research Team. We'd like to show our gratitude to the Port Columbus National Civil War Naval Museum, the Lee County Sheriff's Department, the Lewis Cooper Jr. Memorial Library, the Museum of East Alabama, Springvilla Parks and Recreation and Auburn University. We'd like to thank the residents of Lee County and the cities of Opelika and Auburn for the contributions of legend and folklore and all the individuals who eagerly allowed us to interview them. To all our anonymous contributors, we offer our thanks.

We'd also like to acknowledge the inspirations that drive us to preserve legends and folklore: Kathryn Tucker Windham, Reverend Francis Lafayette Cherry, Horace King and the ghosts of Brookside Drive. We'd also like to express our appreciation for historical preservation and the organizations dedicated to preserving the history of Lee County and the cities of Opelika and Auburn.

Special thanks to our husbands and wife for being a great support team—our biggest fans—and for helping us believe and achieve our dreams. We would also like to recognize and thank our children: Jason, Jared, Tori, Eric, Jordis, Conner and Michael. You all will forever be our greatest material and inspiration. All the time you sat listening to our stories in wide-eyed captivation is something we will forever cherish.

Lastly, we would like to thank the storytellers of our childhoods because without their influence, there would be no ghost stories for us to tell.

Introduction

Lee County, Alabama, is southeast Alabama's best-kept secret. Auburn University serves as a symbol of education, knowledge and legacy. The city of Opelika has a most diverse and unique background, with smaller communities such as Salem and Beauregard representing the roots of Lee County. History is the lifeblood that pumps through the hearts of the people who have made these locations their home for generations.

Lee County is steeped in agriculture, Civil War legend and even World War II stories, shrouded in Native American mystery and shadowed by pines and dusty dirt roads that hold onto its secrets like a long-forgotten time capsule. Time moves a bit slower out here in the country, and the same can be said for the ghosts of Lee County. It seems that even in death, folks like it here. Souls tend to linger like the stories and legends, making Lee County one of Alabama's most dedicated communities and conserving the history of our area, keeping it alive through education, folklore and preservation.

The tradition of folklore in Lee County starts at a singular source and serves as an infinite line of communication to keep the stories of our past circulating throughout history. Revising old slave narratives and talking with the community's older generations can put some of the most established history books to shame. Learning about the "old days" from the people who lived through and remember them is something you can do on any given Sunday afternoon in Opelika. Take a stroll through the historical districts and you'll find that southern charm and hospitality are still alive and well in Opelika. Visit the many antique stores and unique

shops and restaurants (serving up traditional southern cuisine) nestled alongside the railroad tracks on Railroad Avenue, or take a ten-minute drive to Springvilla Mansion on the outskirts of the city for a glimpse of southern architecture. Drive to Auburn University, where friends and neighbors gather for weekend barbecues and tailgating that beckons SEC football fans from all over the country and where everybody greets one another with a "War Eagle" and a smile.

It's a warm and welcoming area that has established itself as a place of beauty, character, industry, intelligence and integrity. It's no wonder the ghosts of Opelika and Auburn stay on after their time is up. It seems that no matter how slow or fast these cities grow, some folks just can't bring themselves to leave.

THE LEGEND OF
SPRINGVILLA MANSION

Just outside Auburn, on a quaint side road, stands Springvilla Plantation, with its haunting and glorious past. Springvilla is a mid-nineteenth-century home built by Horace King, former slave of John Godwin, father-in-law to the property owner, Colonel William Penn C. Yonge. King was a prominent bridge builder and architect who took it upon himself to take in Godwin's family as his own after Godwin's death, due to their fondness for each other and their friendship. The home has incurred its own legendary status, surpassing the true beauty of the building and the genius of King's masterpieces. Property owner Penn Yonge should have been an afterthought to the beauty of Springvilla but for one little legend.

Penn Yonge was known as a cruel master, and he met his demise at the hands of one of his own slaves—or so the legend says. The year 1864 dragged on wearily as the Civil War continued to rage. The citizens of this deep Southern region of Alabama were feeling the weight of the War Between the States. Mr. Penn Yonge, after a long day's work at his fields and quarry, retired to his home. His wife and son were away visiting her relatives, and Mr. Yonge was in the house alone—or so he thought.

Penn Yonge was a notoriously cruel man when it came to his slaves. Growing angry with them on a whim, it seemed, he was quick to administer harsh punishments for almost anything he saw as disobedience. On this evening, one of the slaves had had enough. Earlier that day, the slave had stealthily taken a knife from the kitchen and secretly made his way into the house. He hid himself within a niche at the midpoint of the staircase.

The thirteen steps inside Springvilla Mansion.

The night was dark because of the new moon, and no shadows were cast on the dark floors. Soon, Mr. Yonge closed up the house downstairs and made his way up to his room. As Mr. Yonge ascended the stairs, the slave heard him coming. Though it was dark in the house, Mr. Yonge was not carrying a candle, for he knew his way around. The slave waited with bated breath as he heard his cruel master coming up the stairs. When Mr. Yonge reached the thirteenth step, the slave sprang from his hiding place and plunged the knife deep into his master's heart over and over again, killing him and leaving blood everywhere. Today, a stain on the thirteenth step remains, and no one has been able to remove it.

The overseer and a few other slaves heard the anguished cries and came running. They witnessed the slave jump out the front window of the house. He began to run but was caught by other slaves, who, fearing retaliation for the crime, dragged him to an oak tree in the front yard and hanged him. It is said that the spirit of this murdered slave can still be seen walking the grounds of Springvilla, looking for a way to escape his captors. Inside the home, it is said that the restless spirit of Penn Yonge still walks the bottom level of the home, his phantom footsteps trying in vain to reach the top of those narrow wooden steps.

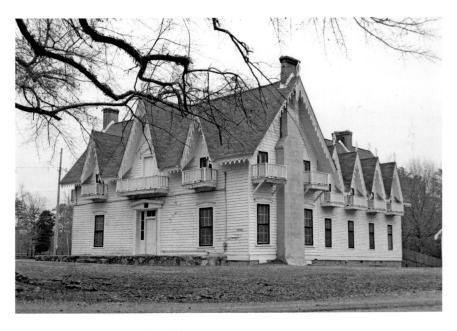

Springvilla Mansion in Opelika, Alabama.

The true history of Springvilla is far more interesting and more haunting than the legend. In the beginning, the original inhabitants of this mystic land on which the plantation was built were the Uchee Creek Native Americans. Here by the lovely creek the natives made their homes and lived their lives of hunting and fishing. They believed that this land was sacred, and anyone who has spent any time in the area would agree. They had their ceremonial grounds close to the creek. They also buried their dead along the banks of the creek; their burial mound can still be seen to this day, but to enter the area of the burial mound is to invite trouble. Many who have visited the burial area have met with misfortune, such as houses burning down, legal troubles and health issues. These peaceful people were removed from their lands by the Indian Removal Act. Some say that the forced removal of the natives put a curse on the land.

The creek that flows alongside the property is reminiscent of a Currier & Ives postcard scene of southern beauty and quaint charm. It became a favorite picnicking spot of many early settlers and their families in the 1840s. It is also an unfortunate spot where tragedy occurred.

It was a beautiful Sunday afternoon, and one of these early families was picnicking along the banks of the creek when four young girls decided they would cross the creek to play on the other side. With parents and friends watching, they climbed aboard an old hand-hewn boat and began to cross the creek. The girls were dressed in their Sunday finest (in the 1800s, this meant they were dressed in many layers). As the girls reached the midpoint in the creek, the boat suddenly sank beneath them. The girls' clothes became heavy from the water and began to drag them down to a watery grave. The families watched in horror, not knowing how to help. One of the men onshore jumped in to try to save the girls, but he, too, was dragged down to his death. The girls were fifteen, twelve and nine-year-old twins; the man was thirty-two.

It was next to this creek that Penn Yonge wanted his home built. He made his fortune quarrying pure limestone, some of the purest in the world. He located the head of the springs and built reinforcement around it to keep the water from eroding the surrounding land. It is still there today. He also built a thirty-acre lake from the spring and creek, which he filled with exotic fish, and invited guests and friends to enjoy the lake on glass-bottomed boat excursions. Mr. Yonge had a love of horses and held steeplechases on his front lawn. He and his wife were known to give lavish parties that were attended by the wealthy of Auburn and Columbus, Georgia. Carriages came along Crawford Road, the only road between

Springvilla and Columbus, to visit the beautiful area. Though the so-called burial mound curse missed Mr. Yonge, he did die in the house of natural causes in 1878; however, misfortune found his son, who followed his father into death two years later. The Yonge family was the only family to live in the house. Mrs. Yonge sold the home to Penn's business partner, who later gave the home to the City of Opelika.

The city would later turn the home and grounds into a public campground. In the 1930s, 4-H camp counselors came up with the legend of Penn Yonge and the tale of him being murdered by a disgruntled slave. Each year, the City of Opelika holds its Halloween Haunted House fundraiser in the house. Many patrons are genuinely unaware that the house is truly haunted.

One eyewitness who was a counselor at the house reported hearing a piano playing in the downstairs front room, and when he went to see about it, he was terrified to find someone there playing an old piano. Other counselors later found him hiding in a corner in the room, afraid to move. Another eyewitness account comes from a monk who, as a child, was staying overnight in the house with his Boy Scout troop. He said that he and two other boys got up together to go to the outdoor bathrooms. It was about 2:00 a.m. when they went to the stairs. As they approached the staircase, they heard footsteps downstairs making their way toward the stairs. At first, they brushed it off as being not yet fully awake. They made their way downstairs, and when they entered the front foyer room, it lit up with a green glow. They thought it was another scout playing tricks on them, but then they realized how cold it was for the middle of July. The monk said that it was so cold he could see his breath for a moment. Then the boys heard a loud *bang!* and saw a shadow go out the closed back door. The monk recalled that the boys ran out of the house as fast as lightning and would not go back in the rest of the night.

During investigations by paranormal researchers, evidence in the form of Electronic Voice Phenomena (EVP)—voices that are not heard by the human ear but are captured on audio recordings—has been uncovered, as have various stills and video images. One of the voices heard on audio was a little girl's mournful cry calling for "Mamma!" and asking questions about who was there. A man's voice demanding that people get out of a room in the house has also been recorded. There is only speculation about who those disembodied voices belong to. Could it be one of the girls who drowned in the nearby creek or Penn Yonge himself? Shadows have been reported outside on the front lawn running around. Could these be spirits

of natives returning to their land? There are images on film captured inside and outside the house. There is video footage of a small, blond boy on the front porch and of a door that shut on its own. There is also a photo of a shadow in one of the upstairs rooms.

Springvilla has a storied history of beauty and tragedy, with legends, ghostly apparitions, disembodied voices and an air of foreboding. This quiet, quaint little house sits in the middle of a campground and park that is largely unaware of what lies within.

THE HIGHWAYMAN

In the fall, when the leaves have changed, this stretch of road on Highway 169 becomes busy with traffic. On Saturdays, the road is alive with people going to see the 2010 BSC National Champion Auburn Tigers. Most modern-day travelers are unaware that there was a time when traveling on this road could involve an encounter with a highwayman.

The origins of this now well-traveled road date back to before Alabama was a state. It was a native trail linking together several tribal areas and hunting sites. As white settlers moved in, the trail became a horse-and-wagon road between Columbus, Georgia, and Auburn and Opelika, Alabama. The road forked, with one branch going to Auburn and the other to Opelika. This road was traveled by all types of people, some very wealthy travelers heading to the plantations of the area. There were at least three known plantations along what is now Highway 169. These were cotton plantations. The ruins of these plantations were last seen in the 1970s; today, either vegetation has overtaken them or they have collapsed altogether. Back then, the road snaked past several creeks, a couple of mills and even native settlements before reaching the two towns. With all this traffic coming through, the temptation was just too much for one man.

Sometime before the 1860s, a highwayman stalked those who traveled this road. He picked his victims carefully, choosing carriages and coaches to rob. The way the road weaved about the area, surrounded by forests of hardwoods and pines most of its length, provided great hiding places for the

Alabama Highway 169 near the Beauregard community.

highwayman. He made several robberies on any given day this road had traffic, but especially on Sundays.

Then one Sunday, he went too far. The highwayman was in his usual hiding spot and had seen a coach coming up from Columbus. He decided to make it his target, but this time, something went wrong. The intended victim was not as helpless as the highwayman expected. When the highwayman pulled his one-shot pistols and demanded valuables, he got a blast from a blunderbuss. It wounded him, but not fatally, either due to pure luck or the inexperience of the shooter. He fired back and didn't miss; one shot killed the passenger, and the other shot mortally wounded the driver. The driver sped the coach to town and lived long enough to give a description of the highwayman. The authorities found the man hiding near Wrights Mill.

The highwayman was convicted of his crimes, hanged and dumped into an unknown grave. It wasn't too long after this that travelers along the road reported seeing a man wearing a long, black riding coat and a wide-brimmed hat riding a horse. The rider would follow the coach or person on horseback for some distance and then suddenly charge the traveler, only to disappear. At first, the authorities believed this was someone who had known the highwayman and was seeking revenge on the person who had turned him in.

But the reports continued to come in, and it was always the same description of a man on horseback charging the traveler and then disappearing. Through the years, as the roadway changed, the sightings became less and less frequent, until now there is only the legend and occasional sightings.

There are also reports of a ghostly rider dressed like a highwayman seen along the highway after sunset. He is visible for a moment and then vanishes in wide-open areas. A couple of eyewitnesses claim to have seen him. One witness said she saw a man on horseback dressed in a long black coat and an old cowboy-style hat cross the road in front of her. It was right at sunset, and at first she thought this was just a rider heading into the large pasture next to the road. When she got to the spot, just seconds after he left the road, she slowed down to get a better look, but there was no one there—just empty pasture. Another witness, a young boy riding home to Salem from Opelika, was looking out the window of the van he was riding in. He saw a man in the large, open front yard of a house. The man was on horseback wearing a long coat and wide-brimmed hat, but it was the middle of summer. He watched the man for a bit, and then suddenly the rider was gone.

The highwayman is not the only apparition seen on this road. There have been sightings of his victims as well. Eyewitnesses have seen a ghost coach following the old road. What makes this unusual is that not all of the coach is seen; nor are the horses that pull it. One eyewitness report comes from three people who had a group sighting—Christine Poe, Kristie Lynn Forester and John Biedermann. Their eyewitness account follows.

The three friends were sitting outside by a lovely early spring fire, roasting marshmallows, telling stories and thoroughly enjoying one another's company. It was the night of Saturday, March 4, 2000. The fire was growing low as the night wore on, and they were getting ready to go inside when suddenly John said, "Listen…do you hear something?" For a moment, Christine and Kristie listened but heard nothing. This was odd because there is always some form of traffic on the road nowadays. Christine was about to speak again when they heard the faint sound of jingling bells. They turned their attention to the front yard, where the sounds were coming from. There, along the road in front of Christine's house on Highway 169, they spotted something moving. They could see legs moving and a light guiding something in the dark. The air had grown completely still. It appeared as if a group of people was out at ten thirty at night with their dogs and riding horses. Christine had seen people riding horses in the daylight hours along this portion of the highway, but to be out in the cold of March at ten thirty at night was highly irregular.

It suddenly dawned on them that another thing about this sighting was very wrong. As the apparition got closer, they could not see humans at all, only something that looked like part of two horses pulling a coach. The three friends stood staring in utter disbelief as the apparition continued crossing the front yard. Neighborhood dogs were silent, the air was sickly devoid of any draft or nightly noise and they were terrified. Christine remembered constantly commenting aloud, "This can't be real." Slowly, the apparition moved down the road and out of sight. They heard no more bells, and all was back to normal. John looked at his watch; it was still 10:30 p.m. His watch had stopped dead.

Could it be that the coach is still trying to reach its destination? Is the highwayman still roaming the road looking for potential victims? Some witnesses believe this to be true. Should you find yourself on the road heading to an Auburn football game or going down to Columbus, beware of the things you may see along the way. Who knows, perhaps you, too, might see the highwayman.

THE LOVE OF CHARLOTTE

Prior to and during the Civil War, Opelika, Alabama, was a growing community. Railroad Avenue was certainly a popular location for a Southern gentleman. During this era, brothels and saloons lined the street. Oil-filled lanterns lit the way along the dusty, red clay streets. The smell of tobacco and cigar smoke filled the night air, while the scent of pungent, flowered perfumes billowed from the upstairs brothels. Lovely ladies dressed in lacy undergarments hung on the arms of wealthy businessmen and occasionally a gunman or even a politician or two. It wasn't uncommon in this time for many upper-class men to have mistresses across town. In fact, it was almost to be expected.

This was the case for one such lady of the night named Charlotte. Charlotte worked as a prostitute in a brothel located on what is today South Railroad Street. Charlotte was said to be a beautiful young lady in her late twenties. She had long dark hair, which she sometimes wore up in a fancy bun with a blue silk ribbon. Her face was round with high cheekbones that showed a hint of Indian, and her piercing green eyes put the most beautiful meadows to shame. Charlotte was a local girl, and in her youth she was madly in love with the son of a local cotton farmer. The two courted throughout their teenage years and planned to marry. Farming for these families was difficult, and the hardships due to the impending war put a strain on both families and on the hearts of the two lovers.

Once news of the outbreak of war reached Opelika, Union and Confederate troops were already being dispatched all over the country. Volunteer units

sprang up on both sides of the war, and small community militias organized to keep a strong hold on farms and plantations. Southern folks were bracing for the impact of what was to be a devastating war. During this time, Charlotte had received word that her fiancé had volunteered for one such unit, which was organized to protect local citizens and landowners from the Yankee forces. Charlotte was distraught at the thought of her beau being in potential danger and set out for his parents' farm to plead with him not to go.

Charlotte was too late when she arrived at the home of her fiancé. He had already left with the ragtag group of volunteer Rebels and was headed east to help intercept Yankee forces. Charlotte was devastated and could not understand why the young man she loved so much had left without even saying goodbye. She traveled home and carried on for the next several weeks in a rather emotional state. She received word shortly thereafter that he was alive and well, stationed just outside Atlanta, Georgia. He also explained in the letter that he had spent some time in Montgomery, Alabama, with the volunteer unit and had signed up with the Confederate army full time. He also told Charlotte that he would return home once the war was over and marry her, just as they had planned.

Charlotte was comforted by the letter but still could not find peace. Several weeks went by, and then months. Charlotte received no more correspondence from her lover. She went to the farm of his parents, where she learned that they had not received word from him in many months either. Charlotte once again returned home with a heavy heart.

Sometime after this, an outbreak of influenza thinned the population of Opelika and some of its more rural residences. Charlotte was an only child, and in fear of her contracting the deadly illness, her parents sent her to stay with relatives in another state. During this time, Charlotte received word that both her parents had died from the flu. She stayed on with her extended family for a short time and then insisted on returning to Opelika to take care of the family farm.

Once she arrived in Opelika, she discovered that her family's farm had fallen into such a state of disrepair that she couldn't possibly take care of it all on her own. With no money to hire farmhands, she was forced to sell her property to a wealthier plantation owner for little to nothing. Charlotte had no formal education and had only ever worked on her family's small farm tending cattle, horses and chickens and helping with cooking and cleaning, as most women did in that day. However, in her young mind, she was determined to make it on her own. She set out to find work in Opelika's merchant districts.

It didn't take Charlotte long to realize her mistake, and within the span of just a few short years, she found herself working, like many other unfortunate women, in the local brothel. Charlotte, now in her early twenties, was a prize to most men seeking company in that time. Her beauty was a sight to marvel at, since she hadn't reached the haggard state of some of the older women. Charlotte kept to the wealthier men in town, who paid handsomely for her company, but she still longed for the young man she so desperately loved.

Though a few years passed, not much changed in Opelika, even in the early stages of the war. There were still supplies coming and going via the railroad. On some nights, drunken patrons and gunmen would even shoot at passing trains from the saloon located directly across from the train tracks. On one particular night, a train carrying several ragged Confederate soldiers quietly slipped into town. This was one of several that would try to make it to Opelika ahead of General Lovell Rousseau, who was under orders by General William Tecumseh Sherman to destroy all railroads between Atlanta and Savannah in his infamous March to the Sea. Upon arriving, the ragged group of half-starved and injured men took up residence in some of the merchant buildings located on South Railroad Street, which included the brothel and saloon. This was a gruesome reminder to the people of Opelika that the war was now upon them.

Charlotte was just one of many members of the community who had come down to help tend to the men who had come in on the train. She fetched water and linens to help dress wounds and baked a mess of corn bread for the tired bunch. She brought the men handfuls of corn bread at a time. She handed out each piece with a gentle smile and kind words to the men who were sacrificing everything for the livelihood of even this small but patriotic community.

As Charlotte made her rounds, handing out the small cakes of bread, she came upon a young man about her age. His hair was long, blond and very dirty. It was tucked under his gray infantry cap. His beard was long and stringy. His face was covered with dirt and sweat, and his cheeks were sunk into the bones of his face. His uniform was covered in filth, and a bloodstained patch covered a terribly infected wound on his leg. As the soldier rolled up his pants leg to reveal the wound, he winced in pain. Blood spilled from the wound and onto the floor. Charlotte quickly ran to the aid of the young man. Dropping her basket of bread and ripping a portion of fabric from the bottom of her dress, she placed the material on the young man's wound to stop the bleeding.

Suddenly, a familiar voice came from underneath the gray Confederate cap of the wounded man. "Charlotte," he whispered. Charlotte suddenly looked up at the face of the wounded man she was trying so eagerly to save. His spellbinding green eyes stared back at hers. Under the piles of hair, dirt, sweat and blood was a man who had once been the boy who left so long ago to volunteer for the Confederate army. She could barely believe what she was seeing. The last time she had seen him, he had been full of life and love. Now, he sat before her slowly dying and trying so desperately to smile at her through the pain. The war had inflicted him with age beyond his own, and his starved body was a shell of what it once was. Still, the love they had felt for each other so long ago remained.

Charlotte threw her arms around his neck and kissed him. She could feel the life leaving his fragile body. She knew what little time she had with him was precious. She was determined to save the man she loved so much. She ordered some men to take him up to her room, where Charlotte would nurse him back to health. Three soldiers raised him up and took him upstairs. She ran to the local inn, where she had baked corn bread before, and gathered kettles of water, clean linens and a bit of food. She ran back to the saloon and made her way to her room, where she found her lover lying in her bed. Scarcely breathing and looking much worse than he had just moments before, his condition was deteriorating quickly.

Charlotte laid out the items, and then she folded her hands and prayed. "Oh Lord," she wept, "spare his life, and I will change mine. I have not been the righteous woman I should have been, and I pray for your forgiveness. But if it's all the same, I'd rather you take my life than his. He is innocent, oh Lord!" She knelt at her lover's bedside and prayed desperately for a miracle. The evening hours grew late, and still Charlotte prayed. Soon, she could see the light of dawn. The clouds were a hazy pink, and Charlotte went to the window to draw back the lace curtains. She opened the window and returned to her lover's side. She spoke to him throughout the night, but he never answered.

Charlotte gently raised his head and fluffed the goose-down pillow under his head. She then washed and redressed his wound. The wound was terribly infected, but he never moved a muscle or winced at the pain. He lay sleeping peacefully, and Charlotte still kept watch over him. Several hours passed, and there was a knock at the door. It was the innkeeper who had given Charlotte the linens and kettle. A doctor accompanied the innkeeper and examined her beloved. Charlotte broke into tears and thanked the two men for coming to help. It wasn't every day that people would lift a finger to

help someone like Charlotte. She thought to herself that her prayers had been answered. The doctor would heal her wounded fiancé, and they would indeed live out their days happily ever after.

Charlotte watched carefully as the doctor and the innkeeper helped examine her love. The doctor first examined the infected wound; he, too, noticed there was no movement from the injured soldier. He glanced across the bed at the innkeeper with a very concerned look. He then placed his hand on the chest of the soldier and placed his ear against his neck and chest. He closed his black bag, and once again, a terrible look of concern came over his face. He turned to Charlotte and said, "My dear, I am terribly sorry, but he's gone." Charlotte grimaced and looked over at her lover lying in her bed. "No! He isn't. He's not dead!" she cried. The doctor and innkeeper tried to console her. The innkeeper said, "Charlotte, he's passed on now. We can't help him." Charlotte would not accept this, as she had been with him all night. She was determined to see life in him. Charlotte let out a scream of disbelief and shouted "NO! NO!" finally collapsing to the floor from exhaustion and overwhelming anxiety.

Charlotte was carried downstairs while the innkeeper and other men moved the body of her dead lover. Charlotte was utterly devastated and spent many days after that in her room, not sleeping or eating. She sat by her window every night, until dawn broke and the pink sun came up, to remind her of the one night she had been given with the man she loved so much. Charlotte later fell into an overwhelming state of depression, and within just a few weeks of her lover's death, Charlotte committed suicide.

There are several rumors about how Charlotte killed herself. Some say she hanged herself from the upstairs balcony. Others say she flung herself from the upstairs bedroom window onto the street below. Either way, Charlotte died a very sad and heartbroken woman. Throughout her very young life, she had been through so much hardship—losing the boy she loved to the military, followed by the loss of her parents to illness, living and working as a prostitute and then finding her lost love and watching him die.

For years, no one has known the name of Charlotte's lover. All that is known is that he was a local boy and a Confederate soldier who was stationed outside Atlanta, Georgia. Upon his untimely death, he was buried on his family's property near Opelika, Alabama. If his body was ever moved from the property, or if a proper military marker was placed at the site of his burial, it is not known. Charlotte was buried in a local cemetery alongside her parents, according to legend. Some speculate that she is buried in Rosemere Cemetery in Opelika, located just off Long Street. However, others say she,

South Railroad Street in Opelika, where the ghost of Charlotte is seen.

too, is buried in a forgotten family plot somewhere in the Opelika area. Today, the story of Charlotte has been revised and retold for over a century. Charlotte's tragedy is one of many lesser-known folk tales, but according to many shop owners on South Railroad Street today, the ghost of Charlotte is definitely not at rest.

For nearly one hundred years, stories of all sorts concerning the ghost of Charlotte have been told. Her ghost has been seen wearing a powder blue dress with her signature blue ribbon tying up her long dark hair in a bun. She has been seen walking up- and downstairs inside the old buildings. She has even been spotted in windows staring at the horizon during the early hours of morning. There have been reports of people seeing Charlotte—or the "Lady in Blue," as some call her—on the arm of a very handsome Confederate soldier. They have been spotted walking together on the sidewalks at night and even on the sidewalk benches, wrapped in each other's arms.

Today, there are a few reports from people who frequent the later-hour facilities on Railroad Street of a ghostly woman who runs frantically from one building to another with blankets in her arms. One patron reported that while leaving a local pub one night, he was approached by a woman in a blue dress with blood all over her. He said she was frantically pacing the

parking lot and then ran into a nearby building. He said he initially thought to call the local police department; however, he declined to make the call when he saw the woman run straight through the locked door of the shop adjacent to the pub.

With all the sightings of Charlotte today, and in years past, it does leave the mind to wonder what amount of truth there is to Charlotte's story. Most of the facts in the story are true, and while there are variations of the tale, one thing has remained consistent throughout the years: not only is her ghost seen and felt on Railroad Street in Opelika, but also her story is one that will live in the hearts of locals forever. Charlotte may or may not have found the love she longed for in life, but in death, the folklorists and storytellers of Opelika have found a place in their hearts for her.

APARTMENT 12

O*pelika* is a Native American word, translated by some to mean "little swamp" and others to mean "big swamp." (Many Creek linguists will agree with the former because the latter is pronounced chak-kè and spelled "rak*kè.") Before becoming the busy hubbub of metropolitan life, much of Opelika was covered in swampland, and some of it still remains. Next to this remaining swampland, there is an active apartment building that holds something so powerful and sadistic in nature that it will rock you to the core. Apartment 12 is what once housed it. The story begins as simply as any ghost story, with minor activity full of pops and howling whispers, easily explained away as the wind by the management.

When a new couple moved in, the activity increased. The couple explained that it began with a photo of the husband. There was a photo that sat on the ledge of the window, along with some photographs of their nieces. It seemed that every time the husband would enter the room, his picture would fall to the floor. After several such occurrences, the wife decided to switch the photograph's place with the photos of their nieces. But still, only the husband's photo would fall to the floor. Believing it must have been a draft by the window, the wife moved the pictures to the other side of the room, on top of the entertainment center, and the activity subsided for about one week. Then one day, her husband came in from work. He leaned down to kiss her, and the photograph of him flew from the entertainment center, hit the coffee table four feet away and broke into pieces. The couple stood there speechless, and then the thought entered

their minds that something else could be going on in their home besides a draft.

They began to discuss the other oddities that occurred in their home. They talked about how the hot water would always shut off once it reached a certain temperature in the kitchen and how the husband could never take a hot shower, no matter what time of day. The water always went cold for him. The wife laughed about the jealous ghost until she woke one morning to see a little girl with long red hair standing over her bed, watching her and her husband sleep.

The girl said nothing, just looked down at the husband. The wife said, "You don't have to be afraid of him. He is a good person and will never hurt me or you." The girl disappeared. Later that day, the couple went antique shopping, and in the back room of a local antique store, the wife saw a portrait of the very girl who had stood over her in her sleep. Needless to say, she was very shocked and upset, realizing that the little girl must have been real and not just a dream like she had thought.

The woman searched the local library for information on the little girl but was unsuccessful in her task. The activity had slowed in their home after this experience. About six months later, the couple moved out of the apartment, and their oldest son's family moved in. They were a young couple with a two-year-old little boy. When they moved in, the activity began again, and this time, it took a strange and sadistic turn. To begin with, sounds of scratching came from the walls of their son's bedroom. He was often screaming, "Leave me alone!" while in his room, and he refused to sleep in there, climbing out of his bed and coming to the living room to curl up on a small play couch. Even when they had made sure he was asleep in his room, in the morning when they woke up, they would find him sleeping in the living room. He always said the monsters wouldn't let him sleep. They believed it was bad dreams he was having, until they began to hear the whispers outside the second-story apartment.

Their bedroom faced the wood line, with no way to their window other than a ladder, yet the voices started to affect the husband. He began acting strangely. He was angry all the time. He looked at his wife sadistically and entranced at times. He said that horrible images began to play in his head, and they upset him greatly. He didn't know where they came from. He said he heard the whispers from the window, and they told him to do terrible things. He went to doctors, but they could find nothing wrong. He began to fight with his wife constantly, and they were at their breaking point.

"The monsters did it."

One night, they were babysitting their nephews, ages three and four. The three-year-old wanted to call his mom, so they let him. He was panicked and said, "Mommy, come get me." The mom said she couldn't, she was working, and he said, "Please, Mommy. I'm so scared here. Please come get me." When she left work and went to the apartment to get her son, she heard her three-year-old scream and start to cry, and she ran into the apartment. Her sister ran to her son's room at the same time. The little boy had scratches down his back. When the women asked the two other little boys, "Who did this?" the four-year-old said, "The monsters did it." The two-year-old said, "I try to sleep, Mommy. Monsters pull my hair, and I cry and cry. We try to play, and monsters scratch him." The mother said, "Oh Jesus, help me!" because she thought the little boys were lying. At that moment, a strange, deep growl billowed out of the bedroom. It was like nothing either woman had ever heard before. The husband entered the room with a gun, thinking an animal had somehow gotten into the apartment. The ladies grabbed the children and ran outside.

The family decided that a blessing might be in order. Calling their church family, they took the children to the grandparents' home, and their preacher began to conduct a house blessing.

During that blessing, events happened that they would not reveal. They said it was too disturbing to repeat, and they did not want to chance the

activity starting up again. They did confirm that the scratching and growling continued throughout the blessing, up until the very end, and the power went out more than once. Once the apartment was blessed, the family lived there for several more years. The family experienced little to no activity, and any activity that occurred was ignored and met with prayers. They refused to repeat any of the stories in the home and told the little boys to never mention them again. In time, the boys forgot about the incidents, and the husband returned to his loving self and never again experienced the strange thoughts or whispers. Later, when the poltergeist-type activity began again, they took no chances and moved out of Apartment 12.

No one who has lived there since was willing to speak about the apartment, but it was apparent to the neighbors that no one ever stayed there for more than six months before moving on. What was it that was unleashed in that home? The history of the land is in question; not much more than the deed to the apartments can be found. Could someone have opened a doorway, allowing frightening events to occur, and if so, how did it get opened? No one will ever know. But be forewarned, if you move to Opelika and the apartment manager offers you Apartment 12, you may want to see if something else is available.

DER HÄFTLING GEIST

The city of Opelika has a rich and varied history. Much of the city's history has to do with the Native Americans who lived here, the Civil War and building a city on agriculture, railroad and industry. One such industry played a crucial role in World War II.

In 1928, Fritz Pfleumer invented magnetic tape for audio recordings in Germany. During World War II, this invention would prove to be of great importance to the Nazis. Nazi spies transmitted secret information with magnetic tape. These reels were smuggled into locations all over Europe by German spies and aided the Third Reich in advancements. This essentially made it a highly prized material to U.S. Army intelligence officials.

The United States would eventually intercept this magnetic tape, and American intelligence officials were quickly able to transfer secret Nazi information to U.S. military officials. They eventually used the German-made product for espionage to help stop Nazi forces.

In 1945, John H. Orr was part of a group of top United States Army intelligence officials who were investigating the technology of magnetic tape. He would later bring his knowledge of magnetic tape back to Opelika, where he formed Orradio Industries and OrrTronics, which produced the lubricated tape used in tape systems and some of the world's very first commercial home, automotive, video, audio and computer tape.

In 1959, Orradio was purchased by the company Ampex. Ampex in Opelika was shut down many years ago and is now no more than a hollow building that stands at the end of Alabama Highway 169 as you reach

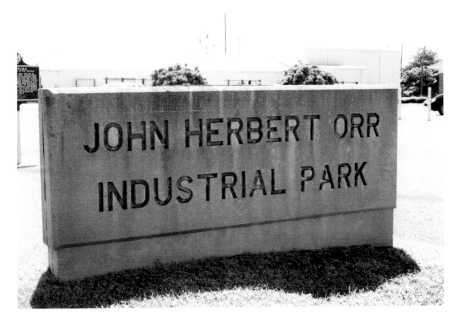

John Herbert Orr Industrial Park.

Marvin Parkway in Opelika. The building serves as a ghostly reminder of the industry that once was the industrial heart of Opelika. The same area was once the heart of another location prior to Ampex. Oddly enough, the very industry that was built on captured Nazi intelligence was built on the property that was once a German prisoner-of-war camp.

In September 1942, Camp Opelika was built on an eight-hundred-acre area to house enemy prisoners during World War II. The camp was able to support some three thousand enemy troops. Upon entering the camp, two large wire fences enclosed the facility, with guard towers situated at the front, right and left corners, in the middle and in the rear of the camp on either side. The camp was equipped with three rows of prisoner barracks, which was roughly 113 barracks shared by enemy troops. The first two rows of barracks also included a mess hall and latrine, with the last row featuring only one latrine. On the opposite side of the prisoner barracks was the POW Infirmary, located just inside the main gate. Warehouses for supplies and shop parts were located in the front, along with the fire department, horse stalls, a lumberyard and even a baseball field. The guards' quarters, the guards' mess halls, a theater, the military police and their quarters, the camp commander's quarters and a latrine were located in the middle, and in the

very rear of the camp, the officers' club, nurses' quarters and officers' mess hall could be found. The camp also included a library, a chapel, a barber and a four-hundred-acre vegetable garden and farm.

The first prisoners arrived at Camp Opelika in June 1943 from Boston, Massachusetts. Most of them were captured in Africa. By June 1945, the camp totaled 3,012 men. Unlike at most POW camps, the conditions at Camp Opelika were very good. Prisoners were treated well and had many freedoms that other POWs did not. They were allowed to partake in activities like theater, where they learned music and put on small stage acts. They played sports like baseball and kickball. They were treated to holiday services, including Christmas and Easter, and were allowed to practice their religious rights. They worked in the camp fields and were paid eighty cents an hour when working and ten cents a day when not. There was a post exchange located at Camp Opelika, where prisoners could spend their earnings on items like cigarettes, stationery, drinks and other items not provided for them by the camp.

Camp officials praised the men in their fair behavior and overall work ethic. They wasted little, according to camp records, and were very fond of bread and potatoes. The prisoners were also educated at Camp Opelika. According to official camp records, the prisoners were taught biology, chemistry, science, geography and bookkeeping and were also being taught English and French.

However, within the camp, there were more than a few rebellious prisoners and even an escape. Two prisoners escaped from Camp Opelika but were later apprehended in Montgomery by the FBI. Approximately ten prisoners within the camp were the source of some unruly behavior. The camp commander requested their removal from the camp on several occasions for many infractions—like threatening physical harm to other prisoners and even trying to organize an uprising within the camp. These same troublemakers also made complaints that they were being treated unfairly due to some Polish prisoners being housed among the German prisoners. They argued that "the Arabs are confined in the same compounds with the Master Race," and they believed the camp was withholding their mail. They also felt as if they were being disrespected by having to wear prison uniforms marked with the letters "PW."

Camp Opelika closed in December 1945, and the remaining prisoners were sent to Fort Benning, Georgia, just thirty-five miles away across the Chattahoochee River. The area has changed much over the years, and time has all but erased the once-bustling camp that existed here. Only a

few camp buildings still remain. One stands near Williamson Avenue; the other one is on the backside of the Ampex compound. Weathered by time and age, most folks don't recollect or have any idea what the buildings once were. The small yellow building near Williamson Avenue sticks out like a sore thumb among the bank and other buildings. It is long and narrow, with points of entry on either side, and was more than likely a warehouse or shop. The other building is located off Orr Avenue on the Ampex compound and is similar in shape to a long and narrow room but with an addition on the front. This building was once the camp infirmary and, in more recent years, served as a computer lab during the time Ampex was a functioning industry in Opelika.

Over the last decade, many people have reported seeing ghostly figures inside the old warehouse building on Williamson Avenue—some while driving by and others while peering inside the windows. These strange manifestations are said to be wearing the same blue uniforms the prisoners at the camp wore, and most have the letters "PW" on the back of their shirts. These ghostly prisoners are said to be meticulously working in what appears to be a shop. In addition, the ghosts of two small children haunt the building—a girl and a boy, both similar in age. The little ghost children have been seen sitting on the front steps and playing in front of the buildings. The barracks were used for a short time after the war to house soldiers who were returning from war and their families.

The Camp Opelika warehouse near Williamson Avenue.

There are other ghosts of the camp that haunt the opposite side of Williamson Avenue. This location was used as the burial ground for prisoners who died at the camp. Camp reports tell of prisoner deaths caused by injuries, disease and natural causes. It is rumored that there was at least one prisoner who died and was buried here at Camp Opelika and forgotten, thus leaving his soul to wonder the property for eternity in damnation. The prisoner's ghost is not a friendly spirit. He is reported to have blond hair set in a slick manner by means of hair oil, a very pronounced jawline, tight facial features and a well-kept mustache. He is dressed in a pewter-colored uniform with Nazi insignia, military-style boots and a small pewter hat with a short black brim.

While he appears to be a man upon first glance, it's said that his eyes glow with a deep red-orange color that seems to burn a strange sort of chaotic fear into the person unfortunate enough to look upon him. His heavy boots are loud and solid, and the smell of sulfur accompanies his manifestation, along with an intense heat that blasts toward you as if hell had just spat him out. He seems to like inflicting pain on the living. Deep scratches and claw marks have been reported on those who have felt and seen "der häftling geist," and strange burns manifesting on the skin with no source have also been blamed on the prisoner's ghost.

Legend has it that he was one of the troublemakers whom camp officials requested be moved to another location due to his violent and rebellious behavior. He was involved in a physical altercation in which he injured another prisoner so severely that he permanently disfigured the man for the rest of his life. The prison guards broke up the fight, but the hostile prisoner also injured two of the camp guards. The prisoner had fashioned a homemade shank in the wood shop from metal tools given to him to build furniture. The guards quickly disarmed the man and sent him to the stockade prison. He later attacked another inmate with a similar device. This time, however, other inmates rushed in to help the prisoner being attacked and beat the perpetrator within an inch of his life.

He spent the next few days in the camp hospital, where he eventually died from the trauma inflicted on him by the other inmates. The guards had the prisoners who beat their fellow inmate to death dig the man's grave in the burial site, and he was given a traditional Nazi funeral, complete with a band and funeral procession. The inmates despised the camp commanders for allowing the man to have a decent funeral, since this particular prisoner had been the source of so much controversy within the camp and wasn't liked at all. After the funeral, the other prisoners would frequently be caught

The old infirmary at Camp Opelika.

urinating on the grave of the deceased prisoner. His grave was even said to have been looted by a few inmates for his personal belongings, which were buried with him.

Even the old infirmary building is not without reports of ghostly phenomena. Retired Ampex workers have reported seeing strange lights inside the building at night, and eerie sounds of the sick and dying have been heard here. This location was the source of many police 911 reports of shouting and moaning, but responding officers would discover nothing. Over time, the reports became less frequent as Ampex began to close down, since there was no longer anyone to report the strange activity, but it's said that the disgruntled POW who haunts the opposite side of Williamson Avenue has also been seen here in a very sore state. A half-dressed man, bloody and bandaged, has been seen here as well. Some say they have seen him standing in front of the infirmary building and in the parking lot.

One report of the der häftling geist (the prisoner's ghost) near the infirmary is especially unnerving. An anonymous prior employee of Ampex said she would not walk alone to her car at night because she had been tormented by the ghost. Upon leaving a late shift in the early morning hours, she was walking to her car when she heard a man's voice ask her for a cigarette. The woman wasn't surprised, since her fellow employees were also leaving, and without even looking, the woman rummaged through her purse for her

cigarettes. As she pulled her cigarettes from her purse, she looked down at the ground in front of her and saw the bare feet of a man standing in front of her. She quickly looked up, and a horribly disfigured man with half-wrapped bloody bandages all over his face stood before her. She screamed, dropped her bag and ran back into the building, where she immediately summoned a guard.

She explained to the guard what had taken place, and the guard called in the disturbance to the county and city police dispatch. City and county police arrived and turned up nothing in their search, but they assured the woman and the night guard that they would patrol the area in case the man returned. They returned the woman's handbag, which she had dropped in the parking lot, and when the woman checked her bag, she found everything there but her cigarettes. The guard proceeded to walk her to her car, where she told him she must have dropped her cigarettes. They searched the entire area but could not find the missing cigarettes. To this day, the woman swears the ghost of that bandaged man stole her cigarettes.

Over time, the men who died at Camp Opelika were buried and exhumed at the request of family members. The prisoners' bodies were returned to their loved ones, and every request was honored except for one. The inmate who had been beaten to death after cruelly maiming his prison mate was left behind. His request, if there ever was one, was swept away, and his body was left to rot in the red Alabama clay. If the story of the prisoner's ghost is true, then some report of the marker that once sat on his final resting place would be on record somewhere. None exists. But the existence of the prisoner's ghost will remain. Whether by vengeance or purgatory, his soul is not at rest and seems to linger only for the purpose of torturing the living.

THE SHADOW MAN AT VILLA BAR

The Villa Bar—or Springvilla Café, as some locals know it—is an establishment that has been serving up booze, southern cuisine and entertainment for the last fifty years. The building is small and closed in, with no windows to the outside, but the single front-door entrance will bring you inside perhaps one of Opelika, Alabama's roughest party spots. Once inside, small booths are situated along the back wall, and wooden stools sit quietly in front of the bar. Electric advertisements and neon signs blink behind the long pool tables and dartboards in the back, and posters of pretty girls in grass skirts decorate the front room. A small stage boasts a collection of great classic country, R&B, hip-hop and southern rock music.

The atmosphere here is one of particular taste for good times and sometimes a bit of trouble. During the weekdays, the Villa is a hangout for locals who frequent the establishment for a bite to eat and maybe a cold beverage. Others tend to come on the weekend when the atmosphere is a lot livelier. On any given Friday or Saturday night, cars pack the small Villa parking lot. Sometimes visitors even park in the roadside ditch just in front of the building. Loud southern rock music pours from the open front door to greet Villa partiers. Most often, these partygoers are met by a very large mountain-of-a-man playfully known as "Chubs." He stands a towering six feet, four inches and weighs over 280 pounds. Though quiet and kind, don't let his name fool you. Upon meeting Chubs, his handshake feels like a steel bear trap, and rumor has it that he once broke up a bar fight with a single blow from his left scarred and gnarled hand, all while never spilling

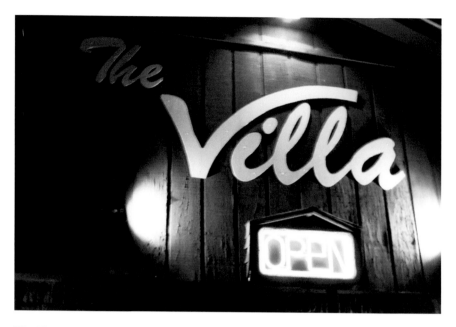

The Villa in Opelika, Alabama.

a drop of the beer in his right hand. A talent worth a prestige award in this establishment!

The karaoke deejay nicknamed "Chilidog" keeps the atmosphere sparked with entertainment by providing plenty of familiar country music sung by local patrons. Bartenders and cocktail waitresses keep up with the heavy flow of beer and whiskey, and doormen meticulously check identifications and keep a careful eye on the crowded dance floor. Familiar local faces come through the door one at a time, greeting one another with fun smiles and warm laughs, and with every clanking glass bottle that gets passed down the bar, the party at the Villa becomes more intense.

Most of the time, the atmosphere at the Villa is lively and full of laughs and good times. At other times, though, the atmosphere can take a very disturbing turn. With any establishment that serves up alcohol alongside a party, there is bound to be some trouble, and the Villa has seen more than its fair share. Physical altercations happen on a regular basis here during the later hours. People who are otherwise very cordial seem to be taken over by a force that's not very pleasant. While most patrons of the Villa will tell you it's just the "let's take it outside" mentality of some of the Villa's more frequent visitors, others say it's something far more evil.

Employees of the Villa report all sorts of ghostly phenomena that take place here almost every day and night. A former cook reported that upon closing the kitchen one night, pots and pans violently flew from their hanging positions on the wall, only to land within inches of her feet. Glasses behind the bar have been knocked onto the floor, where they shattered. Customers who frequent the Villa during the daytime have witnessed their glasses being thrown to the floor by an unseen force. Sometimes customers become so distraught over the glasses that they get up and leave their lunch, returning to work with empty bellies.

One woman found herself locked in a bathroom stall one evening. The bathroom stalls lock from the inside. However, she reported that upon trying to exit the stall, she was hit with a cold blast of air and then could not unlatch the stall door. She became frantic and started to scream for assistance. When another woman in the restroom heard her, she turned to help the woman, only to see the dark, shadowy figure of a man in the bathroom mirror. Startled, the two women freed the latch of the stall and ran from the ladies' room. The same dark figure has been seen by employees when closing at night. The shadow man is thought to be the spirit of a deceased former owner of the establishment. The strange shadow figure

Glasses fly off the bar at the Villa.

has been seen walking across the dance floor and into the kitchen. It has also been seen on surveillance cameras inside the bar. When asked about the shadow man, current owner Jackie Lee stated, "It's no ghost. It's the 'Thrilla at the Villa!'"

Some speculate that the shadow man of the Villa may also be some sort of Native American spirit. Creek tribes that inhabited the land where the Villa is now located once used the land for worship and burial. The area was a holy place for Creek Indians who lived in the area for centuries, until they were removed from their lands by the Indian Removal Act of 1830. Springvilla is known for its abundance of quartz and limestone deposits, which some theorize can contribute to paranormal activity. Quarries where limestone was mined were opened by William Penn Yonge, another legendary figure in Opelika's haunted history, and are located within a few hundred feet of the Villa. The shadow man has been seen on the property adjacent to the Villa, moving in between cars in the parking lot at night and just inside the surrounding woods behind the Villa as well.

No one seems to know who or what this shadow is, but one thing is certain: all who come into contact with it report a very sinister feeling. Cold chills accompanied by rancid smells are associated with the shadow man. Making his presence known to patrons and employees by striking them down with fear seems to be his calling card. This ghostly customer isn't very happy, and he makes it known to all who might cross his path. Even the toughest bouncers and bruisers of the Villa don't like to mention the shadow man for fear he will retaliate in some way. Little is known about this entity, and at this time, no formal paranormal investigation has been done. However, reports of the shadow man continue to flood the tiny Springvilla community. So if you find yourself traveling southbound on Alabama Highway 169 on the sleepy outskirts of Opelika, Alabama, stop in and visit the Villa. No matter how quiet it is, you're guaranteed to never drink alone at the Springvilla Bar and Café.

THE T.K. DAVIS JUSTICE CENTER

Not much else has to be said about the history of a location other than that it housed inmates to know that strange events will occur, leaving even the biggest skeptic convinced that a place will have an eerie feel. Designed by Lancaster & Lancaster, the modern courthouse and detention center was built in 1984 and was named the T.K. Davis Justice Center. The jail is an active prison, and the Justice Center is the active courthouse for Lee County. The Justice Center housed the sheriff's office until 2007, when the Lee County Commission opened the W.S. "Buck" Jones Sheriff's Administration and Detention Center, expanding the already active jail to house more inmates.

Being a working jail, much of the Detention Center's history has been shrouded in darkness and death. Although the jail has not experienced as much turmoil as many older facilities, it has had a few inmates who committed suicide throughout its twenty-six-year reign. Some believe that one or more of these individuals remain. The jail houses violent offenders and mentally unstable individuals on its infamous E Wing, commonly nicknamed "Elm Street" by the inmates and staff alike, exaggerating the personalities of the inmates housed there and comparing them to Freddy Krueger in the film *Nightmare on Elm Street*. Many of the inmates have potential for great violence, and their brutal pasts seem to be personified throughout the facility, seeping into the halls of the Justice Center. This is most prominent when the sun descends and night breathes its dark breath into the marrow of the empty halls. A chilling life all its own emerges,

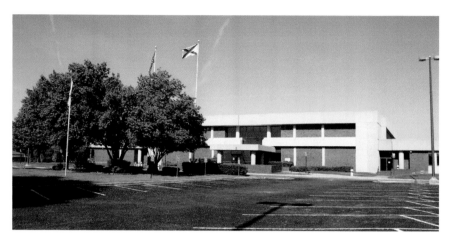

The T.K. Davis Justice Center in Opelika, Alabama.

filled with shadows that don't belong, and all that echoes are the sounds of slamming doors and blood-chilling silence.

None knows better that eerie feel than the employees of the Lee County Sheriff's Office. Dispatchers sat alone in the silence, watching the shadows play games with them on the surveillance system. None was ever so glad to move to the Buck Jones building than these men and women. For years, third-shift dispatchers worked one or two at a time in a small room in the sheriff's office, which was part of the Justice Center. Many nights, at about 3:00 a.m., while sitting in silence, one dispatcher would turn to the small window and say, "May I help you?"—only to find no one there. The building was locked up tight, and no one but deputies or corrections officers could come to that window. Often dispatchers would call a deputy in off the road to check the building for intruders because of bangs and knocks heard down the hall or in the supply vault, and they never could explain why their outside cameras would be turned toward the walls when just moments before they had been turned another direction.

One county clerk even reported walking through a strange white mist in a supply closet that quickly dissipated. What caught her attention was that it didn't feel like dampness in the closet; she could see the mist, and then it was gone, but she felt as if she had walked through a spider web.

The Justice Center was once split into two sections. There was the sheriff's office, and on the other side were other governmental offices, such as courtrooms, circuit clerks' and probation officers' offices. The courtroom

side halls were blood chilling, not mischievous like the sheriff's part of the building. If you were to go to the vending machines at night, you had to walk through the halls of the Justice Center, alone and in the dark. No one was ever comfortable taking that long trek down the hall. Many employees claim to have had a feeling of being watched from the balcony, and often the pay phone would ring when they walked by it, scaring them to the core. One employee stated that she always ran as fast as she could to the big double doors letting her into the sheriff's office. Although it made her look silly, she always felt as if she were in peril and breathed a sigh of relief once on the other side of the doors.

One former dispatcher recalled a legal secretary coming in at night and getting the key to the Justice Center to go to the law library. About five minutes later, he came back, very pale and sweaty. She asked him if he was OK, and he said, "I'm going home." She said, "Well, that was quick. Did you get what you needed?" He said, "Nope. I'm not going to until there is some daylight in those halls."

"Why?" she asked. "Is there someone in the building? Do I need to call someone to check things out?"

He said, "Yes and no. Don't call anyone, but I wouldn't go down there tonight if I were you."

She looked at him, confused, and asked, "Why?"

He slowly shook his head and said, "I'm just going home. I locked the doors, but I don't know if it will help." Then he turned and walked away, without any more explanation.

The Justice Center is still in operation, and the sheriff's office side has been remodeled into offices for the courts. Many might be tempted conclude that the strange experiences were caused by the high amounts of electricity in the dispatch room. But many of the staff of the sheriff's office would have to disagree. If you ask any of them if they would give up their new building to go back to the old days, they will all agree that the ghosts of the W.S. "Buck" Jones Sheriff's Office are much, much quieter. They wouldn't trade their new ambiance for anything in the world—despite any ghostly encounters now being reported at the Buck Jones Building.

The Moonshiner's Ghost

In 1908, Opelika, Alabama, was in a state of reconstruction. Fifty counties throughout the state, including Lee County, were ordered to close down their saloons and conform to a new law prohibiting the sale and distribution of intoxicating liquors. On January 1, 1908, the four saloons located in what is today the Opelika Historical District closed down and went out of business. The saloons were located on Avenue A, North Eighth Street and two on South Eighth Street. These buildings were prime real estate during the dry spell in Opelika, and many business owners were quick to get in the front of the line to purchase such fine locations to expand their own businesses.

Over the next few years, many of these buildings changed hands, and business came and went, but some folks struggled to make ends meet. Farming was still the most common source of income in Opelika and Auburn, but without the taxes generated from the sale of alcohol and alcohol-related businesses, the city of Opelika and Lee County were in a bit of an economic slump. Rural farmers and their families were accustomed to doing things on their own and rarely came into town, unless they were in need of supplies. Rural families living in Lee County traveled into town about once a month with horse- or mule-drawn buggies to stock up on supplies like flour, salt, sugar and medicines when they were affordable. Many rural farmers in the Lee County area came from descendants of earlier settlers who had traveled into the area from places like Virginia, North Carolina, Georgia and other East Coast Appalachian states.

Many of these Appalachian descendants took up making distilled liquors from recipes that had been handed down in their families for generations. Distilling alcohol was illegal in most parts of the state, but rural folks in Lee County found a much-needed cash flow in these alcoholic spirits. These illegal distillers made their spirits under the cover of darkness and by the light of the moon, giving them the nickname "moonshiners."

Distilling their liquors from corn, sugar cane and other starch-based food items, the process would require a pot or still, and the corn or sugar mash would be heated. Steam would travel inside the copper tubing into a separate barrel, called a "thump keg." Inside the thump keg, the steam cooled and would travel into another keg, where cold water would be pumped in, and essentially, a filtered spirit of about 180 proof would be collected. This 180-proof spirit was more commonly known as white lightning, mountain dew or, of course, moonshine.

These mash alcohols were a sought-after commodity for many reasons. People used moonshine to cure illnesses like Pertussis, or whooping cough. An article published in the *Columbus Ledger Enquirer* even mentions Dr. McLain of Salem, Alabama, and another Salem woman who treated victims of the 1918 flu epidemic with large doses of aspirin and gallons of moonshine that were left on her doorstep the night before by an anonymous provider. Of course, there were many moonshine enthusiasts throughout the state who paid moonshiners very well to produce illegal spirits and to transport them as well.

Automobiles were hard to come by in the early 1900s, especially in rural areas like Lee County, Alabama. In fact, the first car in Salem, Alabama, belonged to the local physician, Dr. Andrew McLain. Over time, a handful of other automobiles would find their way through the dirt roads of Lee County. Travelers and moonshiners alike from all over the state used the main road between Montgomery, Alabama, and Columbus, Georgia, for travel and transportation. This stretch of dirt road cut right through Lee County, Alabama, and today that part of the once dirt road is known as Alabama Highway 169. However, some of the county roads that moonshiners used to transport alcohol are still the same today as they were nearly eighty years ago.

Walking these old dirt roads at night can be dangerous for a few reasons. They echo with the sounds of rumbling motors, and on some nights, the smell of 180-proof alcohol fills the dust-covered hollows. Tall pines line the roads, and shadows dance under the full moonlight. There

are some dirt roads that are without any residences. A lack of streetlights makes the old roads extremely dark, and of course illegal spirits aren't the only spirits that can be found in these sleepy hollows.

During late nights, and even in broad daylight, the "moonshiner's ghost" has been seen on several Lee County dirt roads. Perhaps the first story ever told of the moonshiner's ghost came from author Faith Serafin's grandfather, Al Huguley. "Paw Paw," as all the grandkids called him, was a longtime resident of Lee and Russell Counties and also a moonshiner for many years. He followed in his father's footsteps in making moonshine, along with his brother-in-law. Paw Paw would tell stories of his younger days and how he loved to work at his father's still. He would tell the secrets of how moonshiners would leave signs on old dirt roads to let other moonshiners know their load was ready to be picked up and where to take it. This primitive means of communication, known as the "moonshiner's alphabet," was nothing more than broken branches and funny scratch marks on trees or even placing rocks in a particular order on a path.

Paw Paw and Faith, along with her brother and two cousins, were headed home from a local fishing hole one evening. It was starting

"Moonshiner's alphabet."

County Road 144, where the moonshiner's ghost has been seen.

to get dark, and Paw Paw decided to take a shortcut onto Lee Road 144. They had just packed up their cane poles when they heard what sounded like gravel flying against the dirt road. Paw Paw motioned to all the grandchildren to get inside the truck, having no idea what was headed their way. They all loaded into the back of Paw Paw's pickup and hadn't even started the engine when they heard an earth-shattering rumble. They waited for a few more seconds and then, just up the road, spotted a cloud of orange dust. The rumbling got louder and louder, and the sound of spinning tires against the gravel gave way to the sounds of clanking glass. Just then, a shiny black car appeared. It was covered in red clay and dust as it rumbled past them on the old dirt road.

The old black sedan was moving so fast that they could barely see the driver at all, but the clanking sound of glass jars inside the car was obvious as the old sedan spun hard inside the curve of road where they were parked. Paw Paw never said a word but set right off behind the old car to catch a better look. They followed the puffs of orange dust that filled the road in front of them, and to their surprise, just as quickly as the old car had appeared, it disappeared at the end of the road. They never saw or heard it pull onto the highway.

They proceeded home, where Faith overheard Paw Paw telling her grandmother that the car was moving so fast that when it turned the corner, it nearly slung the paint off. Later, Faith asked Paw Paw why the car was driving so fast on that old dirt road. He explained that the car was no ordinary car. He then told Faith that the old-timers used to run moonshine in big black cars like the car they had seen that evening and that the reason he was driving so fast was to get away from the revenuers.

As a child, Faith had accepted his explanation for the old car, but as she got older, tales of the moonshiner were starting to become more and more common. Several teenagers who were out riding on dirt roads witnessed the same black Plymouth sedan with the rattling sound of glass jars on the Old Ghost Town Road from Smiths Station to Salem in the summer of 1998. More reports of strange rumbling sounds that bellowed out of the wooded areas on Lee Road 166 came that following fall, and perhaps the most prominent report came from a local Lee County resident who lived near County Road 240 in Salem. She was a single mother of one and worked two jobs. During the weekends, she worked as a waitress in the evening hours at a local restaurant. When she got off work, it was usually very late, and she would stop at her sister's house to pick up her daughter and then proceed home.

On one peculiar night, she had just picked up her daughter and was headed home when she turned onto the dirt road where she lived. Suddenly, a large black car sped around the corner, nearly hitting her car, and then proceeded onto the highway. She slammed on her brakes and shouted some very ugly profanities at the speeding car. To her surprise, the old car stopped, and the reverse lights glowed bright through the red clay dust. The car backed all the way up to where the woman was parked. When both cars sat parallel to each other, the woman was horrified to see there was no driver at the wheel. She couldn't believe her eyes! Her daughter cried out for her mother to drive, but fear had frozen the young mother in her tracks. She anxiously waited for the car to move on, but for more than a few seconds, she sat looking into the car in a strange panic. Suddenly, the motor of the driverless sedan began to rev and rumble. Plumes of black smoke poured from the tail pipe, and suddenly, gravel and rocks rattled the windshield of the woman's car as the old Plymouth sped off.

To this day, there are still reports of the moonshiner's ghost that surface from time to time. Most local parents tell their children to stay off those old dirt roads. There are far worse things to fear nowadays than

some old, dusty dirt road, but when the stories do surface, they tend to linger, and sightings become more and more prominent. Maybe the old moonshiners who are still distilling these illegal liquors are trying to get their loads of moonshine to their destination in a timely manner. I guess it's true what they say: the early bird gets the worm. Or in this case, the faster moonshiner gets the prize.

SALEM SHOTWELL BRIDGE IN OPELIKA MUNICIPAL PARK

If you travel northbound on Highway 280 near Salem, Alabama, you will find County Road 254. Near the middle of County Road 254 is Lee Road 252. Traveling just a few hundred feet onto Lee Road 252, you will come to a cul-de-sac. The area is overgrown with vegetation in the summer months but bare and visible during the winter. A small dirt trail leads you to a slow, shallow creek that is part of the Wacoochee Creek, and if you look closely, you can still see the concrete pillars left from where the Salem Shotwell Covered Bridge once stood.

This area was once home to some of southeast Alabama's Cow Creeks, also called Halawaka, Wacoochee/Wacoockees and Uchee Creek Indians. A playground of sorts was situated near the area where the natives gambled for cattle in a game known today as stickball. Stickball was played with two teams. Each player had two sticks. Each stick was designed by the individual player and consisted of a stick roughly one to one and a half feet long with a small basket structure on the end. The sticks were folded over at the top of the stick and banded together with animal skin. The basket structure was also made with animal skin. A small ball made from animal skin was filled with deer or other animal hair and stitched together.

The process of the game was simple, but the stakes were high. To start the game, all players would assemble in a huddle, and the ball was tossed into the air by a member-designated official. All players would scramble for the ball, encasing it in between the two baskets of the sticks

they carried. Then the player would launch it into the air toward that player's designated line of play. These games could go on for hours, if not days, and typically it was agreed upon prior to the start of the game how many times a player would need to hit the ball past his or her line of play. Women participated in the sport as well, but they used their hands instead of sticks. It is also said that the women of these tribes took the sport a bit more seriously than the men, frequently becoming upset over "undignified comments" and losing their tempers.

Today, the area is without the Creek ball field but retains the name of Wacoochee. In 1900, Otto Puls erected the Salem Shotwell Bridge to help reroute the distance between Salem and Shotwell, Alabama. This essentially shortened the distance and made traveling between the two locations much easier. The Salem Shotwell Covered Bridge stood more than one hundred years over the Wacoochee Creek. It was vandalized with fire and graffiti on many occasions over the years but stood strong until a storm in 2005 uprooted a large oak tree, which fell onto the bridge, eventually causing it to collapse. The bridge was then salvaged by volunteers from the Lee County Historical society and donated to the City of Opelika, which reconstructed it on a smaller scale. The bridge now spans a small creek in the Municipal Park in Opelika.

There are many legends about the old Salem Shotwell Covered Bridge and some common misconceptions. Many people think that the Salem Shotwell Covered Bridge was built by Horace King, the famous bridge builder and architect who built Springvilla Mansion. Horace King's son, W.W. King, built a bridge in Lee County known as the Meadows Mill Bridge and another that once stood over the Halawaka Creek, neither of which stands today. But there is a romantic and strange flair that comes along with covered bridges. Many covered bridges can be found with horseshoes nailed in an upright position in the rafters, bringing good fortune and luck to those traveling the route. Often painted red, these horseshoes are meant to be talismans used to ward off evil spirits, according to local folklore of Lee County. Other bridges seem to take on an almost mystical feeling, as if the road through an old covered bridge could link one world to another.

This is the case with the Salem Shotwell Bridge. Legends sprang up in its early years, fueled by superstitious locals, of spirits of Indians who had drowned in the creek reaching up and grabbing those crossing the bridge at night, pulling them into the water—clearly a way to motivate people to stay off the roads after dark. However, more tales evolved

Lee County resident Velma Huguley stands in front of the Salem Shotwell Covered Bridge in its original location in 1984.

about the old bridge in the early 1960s. One involved a high school girl who asked her prom date to meet her at the old bridge for a late night rendezvous. Her date never showed, and the rejection was too much to bear. The girl hanged herself from the rafters of the old bridge in her prom gown. Before the bridge was removed from its original location, it wasn't uncommon for high school kids to venture out to the Salem Shotwell Covered Bridge to try to catch a glimpse of the hanging girl or to provoke the native sprits of the Creek.

Later, another ghostly tale of a horrible car crash would come to light. Allegedly, a woman was driving her car on Lee Road 252 when the bridge was still intact. It was late at night and very dark on the old dirt road. It was raining heavily, and the dirt quickly turned to mud and became slick. When the woman rounded the curve at the Salem Shotwell Bridge, she lost control of the car and went over the side of the embankment, crashing into the creek below. This ghostly woman

has been seen wandering the creek banks and has even startled would-be campers in the area with her terrible cries for help. It is said that her ghost drifts just above the water of the shallow creek, accompanied by the smell of burning flesh.

Along with the legend of the woman who allegedly crashed her car sprang up the tale of a child who was apparently killed in the accident as well. The ghost boy was seen occasionally on the old bridge, and frequently, people would leave small gifts and toys for him. For many years, it was a teenage tradition—or perhaps morbid curiosity—to travel out to the old bridge and hold séances in an effort to try to contact the ghosts of the Salem Shotwell Covered Bridge, but once the bridge was destroyed by the storm in 2005 and removed from Salem, the legends and rumors about the ghosts all but died out.

A few other legends sprang up over the years, but one has followed the bridge from its original location in Salem to its new home in the Municipal Park in Opelika. The original bridge was more than seventy feet long, and most of the salvaged material from the bridge was used to reconstruct it in the Municipal Park, although its length has been shortened by several feet.

Not long after the reconstruction of the bridge, reports started to resurface about a ghostly child who wandered the little bridge. Workers reported something that sounded like a barefoot child running once the foundation of the bridge had been completed. Also, the ghostly laugh of a youngster and someone who would frequently whisper in the ears of volunteers, "Come play with me!" were enough to startle several members of the community. The ghost boy has been seen in the small constructed house, also made from remains of the old Salem Shotwell Bridge. He has been seen on the playground equipment and even playing with the other children who frequent Opelika Municipal Park with their families during the weekends.

Since it's not uncommon for most children to make new friends at the park, most parents overlook the imaginative ramblings of their little ones, who tell of the barefoot little boy who plays alongside them and their friends. However, one parent took it upon himself to investigate the claims when his daughter came to him and told him she was playing with a little boy near the bridge. When she described the boy to her father, she informed him that the boy was barefoot and wanted to play in the water. The young girl's father had told her not to get into the water since the weather on that cool January day was very chilly. He was a bit

concerned that the child was without a parent and barefoot in the water. So he walked with his daughter over to the bridge to find the young boy.

As father and daughter walked through the park, an eerie silence swept through the trees. All manner of life seemed to stop just before they came over the smaller bridge that connected the opposite side of the playground to the area were the Salem Shotwell Bridge sat. While the little girl's father overlooked the odd silence, his daughter spoke up and said, "There he is, Daddy!" pointing toward the replica of the Salem Shotwell Bridge. Her father looked, and to his surprise, he saw nothing. He asked her again where the boy was, and once again she pointed and, with a slight giggle, said, "Just there, Daddy. Under the bridge." The man looked again and saw nothing. There was no one there, just the trickle of the shallow creek. The father and daughter made their way up the hill and looked over to the opposite side of the bridge. It was empty.

The man looked down at his young daughter and said, "I guess he's gone home." The little girl just shrugged her shoulders, and they turned to cross the road in front of the bridge to make their way to their car in the parking lot just a few yards away. As they stood in front of the bridge, looking carefully both ways to cross the street, a small, childlike voice came from behind them. "Come play with me!" it said, with a ghostly giggle. Suddenly, the sound of little feet came toward them. As the father stood listening in disbelief, his daughter said, "See, Daddy, he hasn't gone home!" She laughed. "He was hiding from you the whole time!" Startled and shocked, the father worked hard to maintain his composure. He could hear but could not see the young boy his daughter had described. In a composed but internally frantic state, he gathered his daughter and quickly made his way to their car.

Today, the park is active and full of families and events put on by the city, birthday parties and even train rides. Children still play near the replica of the Salem Shotwell Bridge, unaware that a real haunting makes its residence here. A seemingly innocent afternoon can turn into a ghostly experience at Municipal Park. Should the little barefoot boy of the old Salem Shotwell Bridge take a liking to his living playmates, your relaxing day at the park could turn into the experience of a lifetime.

SYDNEY GRIMLETT

THE MOST FAMOUS GHOST ON THE PLAINS

The most famous ghost on the plains is Auburn University's Sydney Grimlett, the ghost of the University Chapel and Telfair Peet Theatre. The University Chapel is the oldest building on Auburn's campus in its original location. It was built in 1851 and served as an annex of Texas Hospital during the Civil War, a house of worship for a Presbyterian and an Episcopal church and later as classrooms after Old Main burned, until the rebuilding of what is now Samford Hall. From 1927 to 1973, the chapel was used as an acting theater. Since that time, many strange experiences have been recorded there. Sydney Grimlett was reported to be both an Englishman and a Confederate soldier, volunteering for the Sixth Virginia Cavalry and later made a captain. In 1864, his unit was deployed to block General Sherman's March to the Sea, and he was wounded in the leg.

Grimlett continued on to the Confederate outpost hospital, which happened to be at the University Chapel in Auburn. While there, Sydney developed gangrene in his leg and perished. He was buried at Pine Hill Cemetery with many other Confederate soldiers. The truth is, no record for a Sydney Grimlett could be found in the Sixth Virginia Cavalry, or in any Texas Confederate muster rolls, although there were some S. Grimmetts.

No one can quite say how Auburn's ghost was given this name or where his amazing story came from. Some point to a psychic the acting troupe called in, while some say the Auburn Players discovered his name

University Chapel in Auburn, Alabama.

during a session with a Ouija board. Nevertheless, the Auburn Players acting troupe has reported loud banging, missing props and costumes, dark shadows and many disembodied voices. The most famous story was of a strange light looming overhead during the English production of *Long Day's Journey into Night*.

Many guests of the theater reported their chairs being shaken. Their pocketbooks were often disheveled or moved, and they often felt chilled breath on the back of their necks and heard slight giggles and snickers in their ears. Often, chocolates were left in the rafters to appease Sydney during the theater performances.

The Auburn Players believe that the ghost of Sydney Grimlett left with the players to Telfair Peet Theatre, which began construction in 1971. The Auburn Players wrote a note and left it in the chapel, inviting Sydney to travel with them to the new theater. Reportedly, he obliged. Since its debut, the Telfair Peet Theatre has been known for its strange events, from flickering lights to doors opening and shutting on their own. The Auburn Players continued to believe it was Sydney playing his little tricks. Attempting confirmation of their suspicions, the players would leave chocolate candies in the catwalks before every performance, trying to appease his mischievous side, just as they had done at the University Chapel.

Many people believe that once Sydney left the chapel, all activity stopped in the building. What many don't know is that the chapel is still haunted. Now opened to the public for worship, prayer, weddings and events, the chapel still holds its own mysteries. In 2008, a local paranormal investigators' group visited the church. They captured electronic recordings of voices and experienced the water turn on and off by itself. One investigator even misplaced her wallet, which had been in her bag when she arrived, and found it in the balcony later that evening. The other investigators insisted they had not moved it. Is it still the ghost of Sydney Grimlett, a Confederate soldier trapped and having a little fun with the visitors of the chapel? Perhaps it is the spirits of the stage characters that remain, left over from when it was a theater.

So often, playhouses have intelligent haunts that play tricks and leave an eerie feeling in the room. Each time an actor gives birth to a character, he lives through it, breathing life into its literary essence, and once the playhouse lights are down, the actor kills his character, returning back into his own psyche. Could an imagination be so strong as to leave behind a "ghost" of his character? How many mischievous Pucks and phantoms of

Michelle Smith hunting the ghost of Sydney Grimlett inside University Chapel.

the opera have been left behind, still performing their lines, still feeling the pain, anger, happiness and sadness fed by the imaginations of actors and patrons alike? Is this why the University Chapel is still inhabited by a mischievous phantom? Is this the explanation of the goings-on at the Telfair Peet Theatre? Some would believe so. Others would believe it's just our imaginations running wild. Maybe we should ask Sydney Grimlett.

SAMFORD HALL

Auburn University is a name related to football, innovative education and longevity of historical heritage. But is it a name often related to mysterious ghostly encounters? Many students and faculty believe it is. Perhaps instead of it being dubbed "the loveliest village on the plains," as it was by Miss Lucy Taylor, then girlfriend of the son of Judge Harper, founding father of Auburn, it should be named "the most haunted village on the plains." One building most often associated with Auburn is Samford Hall.

Auburn University has not always stood on these grounds. Before the streets flowed with toilet paper and orange and blue shakers, before it was not-so-lovingly nicknamed "that old cow college" by the University of Alabama's beloved coach Paul "Bear" Bryant and even before it was Alabama Polytechnic Institute, Auburn University was East Alabama's Male College, chartered in 1856. Its Old Main building stood where Samford Hall is now. Just a few years after its charter, the Civil War began, the school closed and Old Main was converted into Texas Hospital until 1861. It was the death site of many soldiers, mostly of the Confederate troop Hood's Texas Brigade, which was stationed in Alabama.

During the Civil War, there was little action in Auburn and Opelika, except during Rousseau's Raid, a march across the South by Union general Lovell H. Rousseau and his Northern troops. During the raid, General Rousseau's troops burned most of central and east Alabama and stormed through the center of Auburn and Opelika. The raid ended in Opelika on July 19, 1864.

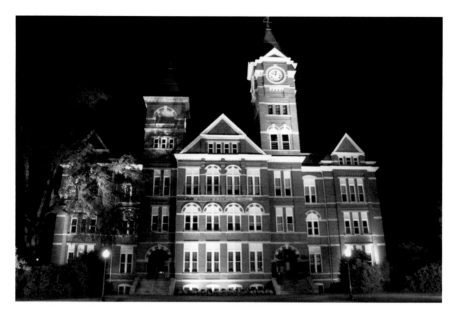

Samford Hall at Auburn University.

The troops had destroyed two miles of railroad tracks, railroad equipment, two train depots and several Confederate equipment warehouses supplying the troops in Atlanta. Rousseau and his troops then turned north and joined General Sherman in his insurgence against Atlanta, Georgia.

Extensive journals, weighing fifteen hundred pounds and stretching over twenty-two linear feet in length, were written by the head surgeon of all Texas Confederate hospitals stationed in the South—Samuel H. Stout. Stout logged each and every soldier he came in contact with, as well as many medical practices used at that time. Stout wrote that once a soldier had passed away at Texas Hospital in Auburn (including those annexed to the University Chapel), they took the body and stacked it on the lawn of Old Main in front of the hospital. Stories passed down through generations stated that the bodies were stacked twenty-five feet across and as high as six feet tall. Later, many of these soldiers found their resting places in Pine Hill Cemetery, Baptist Hill Cemetery (if they were African American) and even in Rosemere Cemetery in Opelika. Many unknown Confederate soldiers' graves are still in these cemeteries.

In 1887, Old Main burned in a tragic fire. The building was replaced by what is now Samford Hall. After the tragic deaths and traumatic experiences

of the land where Samford Hall stands, it is no surprise that spirits of those passed could be trapped there.

The most prominent and active spirit is the ghost of the bell tower. During the Civil War, a guard, usually an already wounded soldier, stood in the bell tower of Old Main and watched over the hospital and all the surrounding grounds. Old Main and Samford Hall have similar structural twin towers, and it is believed that this ghost remains at Samford Hall, forever trapped on the land where he lost his life over one hundred years ago. Some wonder whether, had Samford Hall not been built, the spirit would be seen suspended in thin air where Old Main once stood. There are many reports of a shadowy spirit that haunts the tower.

One Auburn alumna stated that as she was walking across the lawn of Samford Hall one night, she looked up to see the shadow of a man with a rifle on his shoulder standing in the bell tower. Believing that she was in danger, she ran all the way home. When she got home, she told her roommate what she had seen and that they should call the police. Her roommate told her that only a month before, she had had a similar encounter and the man had disappeared in front of her very eyes.

Another story was told by a local mother about her four-year-old son. While on the campus one day, the little boy was playing on the lawn of Samford Hall. Running to his mother and pointing at the tower, he said, "Mommy, Mommy, do you see the man?" She looked strangely at her son. She said, "What man?" and the little boy replied, giggling and waving up at the tower, "The man who is waving at me from up there! He told me that he helped Gabriel burn this building back in the times." The woman stood there in shock. She had no idea who the little boy was talking about or who Gabriel was, but she knew that Samford Hall was not the first building on these grounds. The first building had burned. She also knew not to take the babblings of her son lightly, as children are quite often closer to another realm than adults and are more susceptible to spiritual contact. She asked her son calmly who Gabriel was. He said, "God's best friend." That made her even more confused.

Was there a celestial connection to the burning of Old Main? She asked her son if the man said why they burned the building, and the little boy said, "I don't know, Mommy. Maybe the building was too old."

Is this the ghost of a Confederate soldier standing guard over the wounded at Texas Hospital or someone put there by a higher power to watch over the safety of Auburn students? Either way, the ghost of the bell tower remains, steadfast to his duties, guarding the campus each and every day.

PINE HILL CEMETERY

Nestled just off a quiet side street between a water tower and apartment buildings on a six-acre lot two blocks from the Auburn University campus is the City of Auburn's oldest cemetery. The peaceful, well-manicured, rolling lawn of Pine Hill Cemetery is the final resting place for many of Auburn's famous dead.

Established in 1837, Pine Hill Cemetery was set aside for the settlers and slaves of Auburn's first residents. The land was donated by Judge John Harper, the founder of Auburn. The oldest grave in the cemetery is dated 1838. Among the honored dead are Judge John Harper (1847); Billy Mitchell (1856), who was buried with his feather bed; Jethro Walker (1858), who was mysteriously murdered in his parlor; Dr. George Petrie (1947), who wrote the Auburn Creed; and the only marked grave of a former slave, Gatsy Rice. There are many soldiers from the Civil War to the Vietnam War buried at Pine Hill. In the rear of the cemetery is a mass grave for the Confederate Texas soldiers who died from their wounds at the annexed hospital created for them across from Samford Hall. There are possibly two hundred unmarked graves of slaves and/or Confederate soldiers.

Pine Hill had become run-down over the years. Renovation began in 1994 and is still ongoing. The latest renovation was when ground-penetrating radar was used to help locate the sites of the Texas soldiers' burial area in 2009. Biannual lantern tours are conducted here by the local historical society. Could it be that all this upheaval and portrayal of the dead have caused the spirits of this once quiet corner to begin to

roam about? Strangely enough, although there are no stories or legends connected to the cemetery, there are many eyewitness accounts that would suggest there is paranormal activity.

Walking by the cemetery on the way to a party at a nearby house, a witness saw a green light floating in the middle of the cemetery. She thought at first that it was a car headlight, until she realized that it was inside the fence. The green light floated up and down and then went in between some of the taller, older headstones in the front of the cemetery. It hovered there for a few seconds and then went out like a candle. An amateur paranormal investigator was standing outside one of the two large iron gates taking pictures when she saw something that intrigued her. She saw what looked like a shadowy figure, either rising from the ground or walking up from the other side of the hill. The figure seemed to be coming toward the gate when, at the top of the hill, it stopped by a large cedar tree. It stood there not moving, and then it turned to the tree and walked right into it, not coming out the other side. She was so amazed by what she saw that she forgot to take any photos.

One eyewitness was able to capture something on film. When walking by the cemetery on the way to a house band show to take pictures of the band,

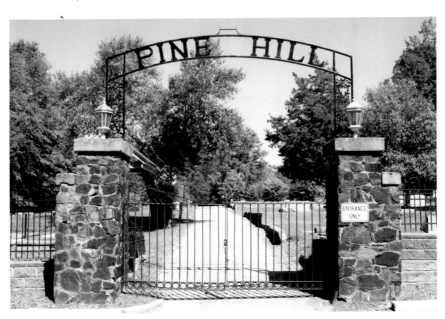

Pine Hill Cemetery, located on Armstrong Street in Auburn, Alabama.

the witness saw something floating right in front of a group of headstones in the front of the cemetery. He watched it for a moment and then had the presence of mind to start taking pictures of what he was seeing. Out of a series of seven pictures, one captured something. The picture shows a transparent gray oval shape hovering above the ground in front of a group of headstones.

A person living across the street from Pine Hill witnessed a group of lights floating in the middle of the cemetery. He thought they were flashlights from kids playing or possible vandals. He decided to sneak in himself and give them a good scare. He was able to walk in through the small front gate that used to be there. He cautiously crept along the hedge line to where the lights were. He watched the lights and saw that there was no one with them. They were just balls of light weaving in and out of headstones. Then, one at a time, they quietly went out. He, on the other hand, did not. He ran out of the cemetery, jumping the fence and racing to his house. He hasn't been in Pine Hill since.

Do the dead roam the beautiful grounds of Pine Hill? There are many eyewitnesses who claim they do. Next time you take the lantern tour of the cemetery, maybe you'll look differently at what you see. Who knows if one of the reenactors is truly a ghost that has come to speak with you.

THE PINETUCKET HOUSE AND MARY ELIZABETH'S GHOST

While leaving Auburn after game day, many people will travel down Wire Road, believed to have been named for the telegraph wire that once ran down it. They will drive by a white house that once flourished in grandeur and beauty on a large hillside (which has since been leveled out by the road extension) and will likely not notice it at all, except for perhaps the white pillars peeking out from the vast foliage that covers the home. They will also likely not notice the small family cemetery, which the road now separates from the family home, now part of Auburn University's property, tucked away behind a gate and only frequented by the cattle.

This little house is named Pinetucket Plantation, and the city of Auburn has slowly swallowed the twelve hundred acres it once possessed. Built by Lewis Foster, brother-in-law to the original owner, Gregory Nicholas Cherry, Pinetucket has held the laughter and the tears of the Cherry-Foster lineage for at least seven generations.

Incidentally, Gregory Nicholas Cherry is the son of Reverend Francis Lafayette Cherry of Salem, Alabama, who was the author of *The History of Opelika and Her Agricultural Tributary Territory* under the pen name "Okossee," a name given to him by the Cow Creek Indians. *Okossee* is believed to mean "bear" or "river otter," depending on the variations of Creek language. It was this history-rich family that tragedy struck, and the image of a child was burned into the very marrow of Pinetucket's legacy.

Mary Elizabeth Cherry, born on September 10, 1898, to George Nicholas Cherry and Florida Mae Foster, was a loving and playful child. At the tender

The Foster family cemetery, located on the former property of Pinetucket Plantation.

age of four, she slipped in the breezeway of Pinetucket, hitting her head on an iron trough used to water horses. After some time, the girl died in 1902, of what was believed to be blood poisoning. The Cherry family soldiered on, having four other children, all of whom lived to adulthood, but the family never got over the death of young Mary Elizabeth. We know this because her story was passed through all seven generations who lived in the home, more than likely because they believed she still walked the grounds of Pinetucket, carrying a lantern wherever she went. That glowing light is often seen on the grounds of the home today. It is believed by many that after such a tragedy, the living cannot let go of the dead, and they hold the spirit of the deceased in their hearts so tightly that they keep him or her from moving on.

Is this what happened to Mary Elizabeth? The family of Pinetucket believes so. They believe that Mary Elizabeth is not the only spirit in the home. Heavy footsteps and mischievous acts often occur in the house. But the spirits that remain are members of the Cherry-Foster lineage, and they are welcomed with open arms by their living relatives, the namesake of Mary Elizabeth and her family, who live in the once grand home overlooking Auburn University.

One question that remains is where is Mary Elizabeth's grave? Both George Nicholas and Florida Mae are buried in Pine Hill Cemetery, and many of the Fosters are buried in the small family cemetery. Some suggest that Mary Elizabeth was laid to rest by her mother at Pine Hill Cemetery, but without a marker, one can't help but wonder if this is why the child cannot rest. Does she long to have her name recognized and her story told? One thing is for certain: Mary Elizabeth still makes her existence known at the family home, dancing and playing with her light shining bright.

ROBERT TRENT JONES AND THE GHOST OF MARY DOWDELL

After the abolishment of slavery, Pompy and Susan Dowdell and their children—Pompy, Silas and Mary—went to work for Johnny Lipscomb, a freed slave who had bought several acres of land in Opelika for a dollar an acre. That land was sold by his family in the 1940s to the Opelika Water Works and was later turned into the Robert Trent Jones Golf Course. Still on the land is part of the old Lipscomb homestead and one remaining grave, that of Mary Dowdell, buried in 1905, who passed at the age of ninety-five.

Mary is said to haunt the golf course and is known as a force to be reckoned with. Urban legend states that Mary was abused as a child by the foreman on the plantation where she worked. Afterward, she was always fearful of white men. For years, golf has been considered a predominantly white male's game, and many of these men in Opelika believe that Mary exacts her revenge on their golf games. They believe if you say something nice to her near her grave when on the course, your game will be good; however, if she hears you swear, your game will be doomed. Many players state that their balls will go missing, as though disappearing into thin air. A local golfer claimed that once, on the seventeenth hole on one of the courses, he saw an old woman peeking from behind a tree. When he yelled "Fore!" at her, she disappeared right before his very eyes. He cursed out of shock and then laughed it off, thinking he was seeing things. But when he swung at the ball, it disappeared too, before he ever made contact. Still shrugging it off as squirrels or something, the man continued to attempt

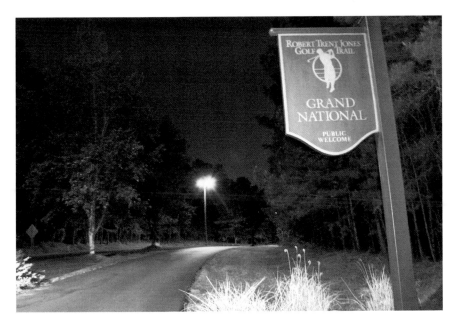

The Robert Trent Jones Grand National in Auburn, Alabama.

to tee up. After he lost four balls, he packed up his clubs and left, swearing that he had been affected too much by the hot Alabama summer.

Mary is seen from time to time on the grounds of Robert Trent Jones in a white mist, pockets of her dress full of what are assumed to be golf balls. Perhaps she is upset that she can't rest because of the sound of swishing clubs and the laughter and swearing of white men all around her. Maybe Mary steals their balls to make them leave. No matter her motivation for the golf ball collection she has hidden somewhere, when playing on Robert Trent Jones, if you want a good game, watch your p's and q's. Be sure to say something nice to old Mary, or your game might not make it to the eighteenth hole.

THE LEGEND OF CHEWACLA

In 1938, a Federal Writer's Project was commissioned to publish the last remaining stories of American slavery told by the last living freed slaves, most of them late in age. The youngest of them were around sixty-five or seventy years old. The language of *Slave Narratives: A Folk History of Slavery in the United States from Interviews with Former Slaves* was crude, recorded just as the slaves were interviewed, with racial slurs and cultural dialect in tow, but it was full of important and historical information, never truthfully written about before and crucial to the integrity of history in the United States. But part of that very great story is missing—the part about what happened years and years before these men and women interviewed were even thought of. A piece of American history that some of the most educated may not know. Slavery was not just intended for the white man, the colonial settlers of this great nation, but also for the native population already settled on this land. This included the Creek Indians who lived in what is now Lee County.

The Indian Territory in Alabama up to 1823 included Upper Creek and Lower Creek, Choctaw and Cherokee tribes. The Upper Creek settled into Lee County in "towns" that often moved along rivers and creeks. The towns were often moved when they became overpopulated due to overworked farmland, rodents, insects and human waste problems, but they usually kept the same name. The towns included a mound-topped rotunda in the center of the community. The rotunda was a conical building, thirty feet in diameter, made of poles and mud and used for council meetings and festivals, such as the Green Corn Festival (an important ceremony by many

native tribes when the corn would first ripen that included a feast before fasting, dancing and sacred drinks).

These Creek tribes were matriarchal in lineage, and the women were often the chiefs, council members and landowners. Though it might seem odd to today's patriarchal society of the United States, these women were also African slave owners. A legend passed down from the few Creeks left in this area is the story of Princess Eccuse HvSe, whom we will call Sun; her mother, Heneha Lvmhe, the second chief of the town (in the Cheaickoochee Creek tribe), whom we will call Eagle; and the slave boy Pao.

It so happened that Sun was beginning to come of age to marry, and the council and her mother, Eagle, had to choose an appropriate candidate to be her husband. "He shall be a great hunter," Eagle said to the council. "We will send a group of boys out with the men this winter; whoever brings back the biggest game shall have her hand."

The council agreed to the terms, and Sun was told of her fate. Sun was prepared to follow her mother's orders. After all, she was the second highest in command in the entire tribe; her word was as solid as stone and could only be overridden by one.

Fall passed away, and winter came upon the tribe. The men all went out to hunt and left the women and one slave boy named Pao behind. Sun was assigned to watch over Pao while the men were away. She was to make sure that all his duties were met. Over the course of the winter, and much to Sun's dismay, she and Pao fell in love. Of course, it was forbidden for them to be together, with Sun having such prestige.

It was not uncommon for members of the tribe to have "consorts" who were their slaves, but none who was so high up in the hierarchy of the tribe. Sun and Pao began to steal secret moments together, especially near the river, now known as Chewacla. Upon her return at the end of winter, Eagle had chosen her daughter's new husband. His name was Chewacla, and he was a great hunter. They were to be married the very next day, and Sun and Pao decided to run away together. They were to meet at the river and follow it north, closer to the Cow Creek tribes of Salem. When they met, they were seen by Chewacla, and he and many more members of the town began to track Pao. For days, they hunted Pao, as if he were a great big buck, climbing down the deep ravines and across the vast wilderness.

At this time, the other men who were tracking with Chewacla gave up and urged Chewacla to return, stating that the boy was long gone, but Chewacla vowed that he would not return without killing the boy who had taken what was to be the greatest prize in all the land.

It is said that just when Chewacla had his eyes set on Pao, a great earthquake came, tumbling down large boulders of granite and creating a large ravine, placing Pao and Chewacla across the river from each other. Pao escaped. He found a cave created by the rocks, and there he hid and lived for months. The problem was that Chewacla had lied to Eagle and to Sun. He could not go back empty-handed, so he killed a rabbit, smeared his body and weapon with blood and returned to the town, swearing that his vengeance had been exacted on the African boy. For months, Sun was in mourning. Even though she and Chewacla had been married not long after his return, secretly in her heart, she was saddened by the loss of her love.

A day came when she decided to travel to the ravine where her love was killed and throw herself into the river, to be swept away by the currents, never to surface again. As she stood on the banks, she heard her love's voice. Pao had appeared on the other side of the river. She was so excited that she began to hop across the great boulders to get to her lover, ignoring his warnings of the dangers of the river. Midway across, Sun slipped and fell, hitting her head on a great rock. She was swept away by the currents, just as she had intended before discovering her lover.

Pao could not get to her, and she drowned. Stricken by his sadness, Pao returned to the town, hoping that Chewacla would kill him. That was exactly

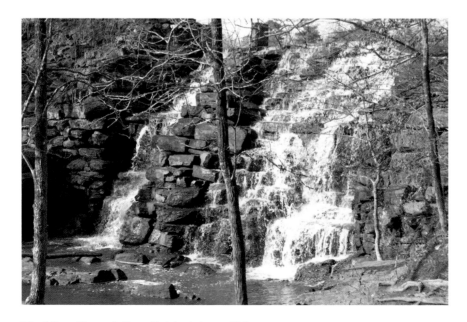

The falls at Chewacla State Park in Auburn, Alabama.

what happened. He was seen by Chewacla and Eagle both. Immediately, he was struck down by Chewacla, but Eagle was so angry at Chewacla's deception that he was exiled from the community. Pao was stricken before he could tell Eagle of her daughter's demise, and Eagle never knew what happened to her daughter.

Defeated and exiled, Chewacla found himself at the river's edge, sobbing and whipping himself with branches. Suddenly, he looked up and saw his wife, Sun, standing on the rocks in the center of the river, beckoning to him. Rising and slowly crossing the rocks, Chewacla went to his lover with disbelief. Suddenly, Sun disappeared, and with a lunging motion, Chewacla slipped and fell into the river to be swept away by the current. With his demise, Sun and Pao's revenge was exacted, yet Sun often returns to the rocks.

Today, Chewacla is an Alabama State Park that includes a 26-acre lake; 696 acres of hills, valleys and rugged, deep ravines; walking trails; and campgrounds. In 1935, the Civilian Conservation Corps built six stone cottages for camping and a stone dam that the water falls down. Often, when visiting the waterfall, people report seeing a young woman running across the rocks and disappearing before she gets to the other side. The rivers and streams have claimed untold lives over the years, and numerous car crashes ended in the water below, but many still believe the girl seen running across the rocks is the great Princess Sun, so close to being united with her lover.

So who is the girl so often seen at the waterfalls? What we do know is that she is forever running to something or someone, open armed, but always falling short. Like so many, she is a victim to the waterways of Chewacla.

THE LEGENDARY
CONFEDERATE CAMP WATTS

Two memorial tombstones are the only reminder of what once was
here. The mules, the tents, the soldiers and the wounded were all
part of this now private pasture. "Camp Number One of Instruction,"
better known as Camp Watts, was the stuff of legend, making men of
boys and sending them to their untimely graves.

Camp Watts was one of the many training grounds in Macon County,
Alabama, for young men during the Civil War. It was commanded by
Major William G. Swanson in 1862. At one time, Auburn was considered
part of Macon County, and Camp Watts's history is relative to the men
and women of Auburn, now in Lee County. It had temporary buildings for
two to three thousand men, along with wall tents, a railroad and station,
a grand cemetery and a hospital. The cemetery cannot be pinpointed
since the slaves who worked the land moved the stones without moving
the graves. The most famous of the buildings on site was the hospital,
because after General Lovell Rousseau came through, it was the only
building left standing.

Rousseau came through Alabama in 1864 with about twenty-three
hundred men from the Union Armed Forces, and his sole mission was to
cripple the West Point Railroad. During this mission, known commonly as
"Rousseau's Raid," Rousseau and his troops burned cities by the dozens
all the way from Montgomery and up toward Atlanta, Georgia. Some
of the cities burned were Notasulga, Loachapoka, Beauregard, Opelika,
Auburn, Chehaw, Decatur, Greensport and Ten Island Ford, which

The remaining markers of the Civil War dead, just outside Auburn, Alabama.

was completely destroyed. During his raid, Rousseau met opposition at Chehaw and was forced to retreat to Camp Watts with wounded soldiers. At this time, he burned the camp, the well, the railroad station and the barracks. He spared the hospital but left them with little supplies and no well. Journals of personnel stationed at Watts talked of high water, so water may have not been an issue.

If you try to find Camp Watts today, you will only find private pastureland, fenced off and full of cattle and very large bulls. It is almost impossible to find where the hospital would have been on the acreage. You can see where an old dirt trail might have led to a general store or the depot, but how far back it went, no one knows. Needless to say, the hospital may have been downwind from the general barracks and the cemetery near the hospital. Other than that, very little evidence has surfaced on where the camp was located. The majority of records are in the library of the University of Texas–Austin, in the Samuel H. Stout collection. Any records in the town of Notasulga were burned in a fire years later that engulfed much of the town.

At one time, the land was riddled with grave markers, buckets, horseshoes and other litter, but as the years went by and the 320 acres

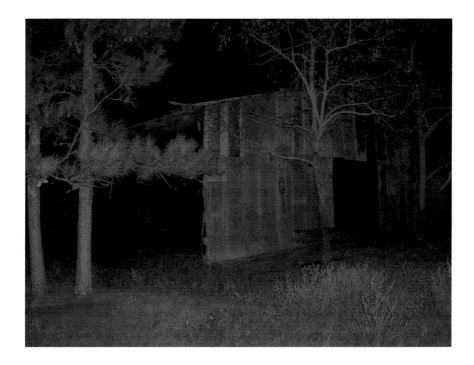

were turned into farmland, the markers were removed, the fields were cleared and the legend became no more than a ghost, perhaps literally. The land has exchanged hands many times throughout the years, but each owner can tell you the same thing. Come at night and listen. The sounds of cannon fire and men talking, laughing, crying and yelling echo over the sound of the cattle, sometimes so loud that even the cows jump at the phantom blasts of cannon. Due to the bulls, investigating these sounds has proven nearly impossible. Walking 320 acres and trying to pinpoint the exact origin of the sounds is not only stupid, but also illegal without permission from the landowner.

Few individuals have been granted permission to come onto the property. Auburn University has conducted research on the grounds with ground-penetrating radar, which revealed several possible mass grave sites. There are no plans to excavate the grounds; however, this does establish the potential for paranormal activity, and some questionable evidence exists in the form of a ghostly photograph.

Camp Watts was added to the Alabama Registry of Military Heritage on May 1, 1979, but was long before in the hearts and stories of those in Lee County. While traveling down the road, you can almost feel the

air change as you approach the field. If you did not know its history, you might blow it off as indigestion. But knowing the history, knowing the fright, the fight, the bravery and the death suffered on this land, even a Northern sympathizer would stop, turn off his car and say a prayer for the thousands who perished at the hands of a gripping war. They were laid to rest here at Camp Watts, Notasulga, Alabama, trodden on by cattle and long since forgotten.

THE AUBURN TRAIN DEPOT

The principal means of transportation for Auburn University students for more than one hundred years, the Auburn Train Depot was built in 1904 in the Richardsonian Romanesque style and designed by architect Ralph Dudley. It was the third depot built in Auburn since the rails came in 1847 and sold its last passenger ticket in 1970. Since its passenger-carrying demise, the depot has been owned by several businesses and now sits vacant, susceptible to the elements and vandals alike. It was listed as one of the most historically endangered sites in Lee County and was listed as a place in peril in 2004.

Perhaps the reason the depot cannot seem to hold an owner for long is the phantoms that roam its grounds. Several stories have arose about the depot, and urban legends make such silly claims as no matter which way you go in the depot, you always come back to the same spot. But most unknown is the story of the lovers who wait for each other and the phantom train whistle, often heard during the day on Saturdays when the weather is just right.

There is a story told by an old Auburn historian of a young woman who visited the train station to pick up her brother, an Auburn cadet. While there, she met a young man who was also a cadet. For months, they would meet at the station, and eventually they fell in love. The problem was that the girl's father wanted her to marry another man. After some time, they decided they would meet at the station and run away together. The young man rushed toward the station to meet her, but her brother had learned of their plan and followed the young man to stop them. The two men began to fight, and in a

The Auburn Train Depot in Auburn, Alabama.

fit of rage, the brother killed the young man. Not wanting to go to jail, the brother threw the body of the young man down a nearby well and ran. The well was very close to the depot, and the young lady witnessed her brother's dastardly deed. The young lady screamed out in pain for the loss of her lover and her brother's betrayal. .

Unable to go on, the girl ran down the tracks out of sight and lay down across them. The train conductor blew his whistle as quickly as he could, but he could not stop the train in time, and the girl was killed. Now people often report the sound of a wailing woman and a phantom whistle of a train, heard some distance from the depot. Not many people pay attention to it, because trains are still a common sight rolling by the dilapidated depot. Some stop their cars and look down the tracks one way and then another, then shrug it off and go on their way. But if you are ever stopped at the depot, you just might hear the faint wail of the woman and feel her pain for the lover she lost and the brother who betrayed her.

THE GHOSTLY FRONTIERSMAN

Before 1836, Salem, Alabama, was inhabited by Native Americans of the Creek tribe. The Indians who made this area home had done so since archaic times. Generations of Creek Indians migrated and lived in this area. Its fertile soil, rivers, lakes, small ponds and wildlife made it an ideal location for human habitation. Lower Creek tribes, or White Sticks, were a peaceful people mainly made up of farmers, gathers and hunters. Lower Creek Indians were not considered a threat to white settlers, and most early settlers in the area lived in harmony with the Indians.

On the other hand, Upper Creek tribes were considered very hostile and inhabited the lands just north of Salem, Alabama, in what are present-day Phenix City, Alabama, and Columbus, Georgia. The Upper Creeks, also known as Red Sticks, were in almost a constant state of war with their Lower Creek neighbors. The majority of the Creek tribes were removed during General Andrew Jackson's raid, which forced most of the Upper and Lower Creeks back into what is now Wetumpka, Alabama, where they surrendered at Camp Jackson (now known as Fort Toulouse).

White settlers from the North and Northeast United States began traveling south and settled in Salem, Alabama, in 1835. Most of the settlers lived alongside the Lower Creeks with little to no problems. Occasionally, outbreaks of aggression and disturbances were reported in the early days of Salem. Living on the frontier was hard. People depended on their crops and what food could be hunted off the land. White settlers found the frontier way of life complicated, especially in the wake of unpredictable and sometimes hostile Indians. Sharing the land with these native people wasn't easy.

Perhaps one of South Alabama's greatest frontiersman stories is that of Eli Stroud. Eli Stroud was born in 1789 in Jackson County, Georgia. He married Elizabeth Durbin at seventeen years of age and moved to Conecuh County, Alabama, with his new bride, living among the Indians in that area. There was relative peace among the white settlers and the Indians until about 1813, when hostilities arose, and an outbreak of destruction and murder took place. Eli Stroud was committed to law and order, and when the State of Alabama called for volunteers to control the Indian outbreak, he was more than eager to oblige.

Mr. Stroud's trusty sidekick was that of a long-barrel rifle. It had been in his family for more than seventy years. It's rumored that this rifle had brought down more than one thousand deer and that Mr. Stroud was an excellent marksman, killing as many as eleven turkeys in one shot. With his trusty rifle, he was made captain over a small division of volunteers throughout the Indian Wars. His avid sense of adventure and background as a frontiersman made Eli Stroud the perfect individual to lead Alabama's volunteers against hostile Indians. What Eli didn't know was that his adventurous soul would soon be put to the ultimate test.

One afternoon in 1818, while in the midst of a hostile Indian uprising, Mr. Stroud was called to duty, along with his volunteer unit, to control the outburst. The Indians had become angry with the white settlers over the distribution of silver for lands once owned by Creek Indians. Also, the abundance of "fire water" made and sold by settlers to Indians didn't help already flaring tempers. The Indians knew that little to no law was available to protect the settlers. With no regard for the "Pale Faces," Indians began to run wild, and the settlers feared their unpredictability.

Eli Stroud was en route back to his home after visiting family in Georgia on March 13, 1818, when he happened to meet his longtime friend Mr. William Ogle on a road. William Ogle offered his home to Eli Stroud and his family for the evening. Knowing that the road home was dangerous and still more than twenty miles long, Eli took William's offer to stay. They spent the evening with their families in true pioneer fashion. Around the campfire, they told stories of the dangers of frontier life and the passing of friends and family who had lived the hard life of the frontier. They talked of the trials and tribulations of living with the natives and their hopes of making a better life for their families.

While Eli and William sat in conversation, the friendly laughter of the two men caught the attention of a handful of disgruntled Indians, who were lying in wait just inside the surrounding forest. They made their way closer

to the house and sat quietly, watching Eli and William. Upon standing, Eli began to feel as if they were not alone. His change in attitude sparked a cautious stance from William as well. A moment of silence was violently interrupted when suddenly the Indians sprang from the forest. Horrible screams and whooping erupted from the darkness. Then, the horrified men saw the Indians, armed with tomahawks and small-caliber rifles, running toward them. A sudden panic-stricken chaos ensued as the women ran inside the home in a desperate effort to try to save the children. William grabbed his rifle and began to fire on the angry assailants but was shot down on his porch and killed almost instantly by one of the crazed natives.

Mrs. Ogle, Elizabeth and Eli, along with the children, barricaded themselves inside the Ogle home in the vain hope that they would survive this savage attack. The attempt was short-lived as the Indians made their way into the house just moments later. The raid lasted only seconds, but in that time, Elizabeth Stroud and her infant child were slain by the angry mob. Elizabeth was scalped and left for dead alongside Mrs. Ogle and her six children—all murdered at the hands of bloodthirsty Indians, save one. Eli knew that in the chaos there were only seconds to save his life, so he ran out the front door of the house and into the forest.

Eli was distraught, mad with fear and blinded by pain and panic. He hid himself in a hollow log for hours. Praying for the light of day and that God would spare his life, grief stricken at the loss of his wife and child, he lay in that log until he could no longer hear the screams of his murdered friends and family. When all the awful whoops and cries of the Indians had faded, he crept from his hiding place, exhausted and terrified. His home was more than twenty miles away, and traveling the road was dangerous, especially on foot and in no more than his nightclothes. Eli made the decision to stay on the road in the hopes that someone would find him.

As he walked down the dusty road, he heard the familiar sound of beating hooves. He made his way a bit farther up the road and caught a glimpse of a wagon. He ran, spirited in his effort to gain the attention of the people on the wagon, but he wasn't met with the hospitality he had hoped for. His horrible condition was not at all pleasant, and the people inside drove him aside like a mangy pup. He begged and pleaded with them for help, and again they denied him, fearing that he may be a madman. Eli was once again alone as he watched the wagon disappear in a dusty cloud.

Eli was without even the most basic necessities—he had no food, no water and not even a warm coat to keep the cool night air from chilling him. Somehow, against all odds, he made his way through the wilderness

for three days and finally reached his home. He was relieved and was taken in by his community and given a hero's welcome. Eli's warm homecoming was short-lived when the initial relief of surviving in the wild for three days wore off. The grim reminder of his slain wife and child was left burned in his mind. Their screams still echoed in his head, and Eli was never to be the same man he had been before that awful night. Eli lived the next several years in seclusion.

In 1820, Eli met and married Elizabeth East, who blessed him with four children. They lived in Conecuh County, Alabama, until Elizabeth died of illness in 1827. He married again in 1830, to Miss Eliza Perry. Eli brought his new wife and family to an area near present-day Salem, Alabama. Mr. Stroud lived well into old age and died at the age of eighty-three on February 21, 1871. He was buried in the family cemetery located on the corner of Stroud's crossroads, just outside the community of Smiths Station, Alabama. The stone in the cemetery that marks his grave once read:

This spot contains the ashes of the just,
Who sought no honors and betrayed no trust:
This truth he proved in all paths he trod,
An honest man's the noblest work of God.

Today, the cemetery is not a spectacular site, but it is still interesting to see. Large amounts of granite exist in the terrain naturally, making awkward formations, and one has to wonder how in the world they could bury anyone here. The hard, stony ground would make it difficult for even the best spade to penetrate the rock. A single magnolia tree grows in the center of the stony ground among the graves. The ground stays covered in large magnolia leaves, making it a haven for snakes, spiders and all types of unusual life forms.

While Eli Stroud has been dead for more than one hundred years, many reports of ghostly sightings near the Stroud family cemetery suggest that old Eli may not be at rest. Several travelers and locals who live near the area have reported seeing a very tall, slender man roaming the cemetery with a spectral hound. While the ghost of Eli Stroud seems to be the most well-known resident haunt in the old cemetery, there are other reports of a ghost child having been observed there as well. Dressed in prominent eighteenth-century clothing, she has been seen dashing in front of cars traveling past the cemetery late at night. There are also eyewitness accounts of the same ghost girl stopping passing motorists and asking, "Where is Papa?"

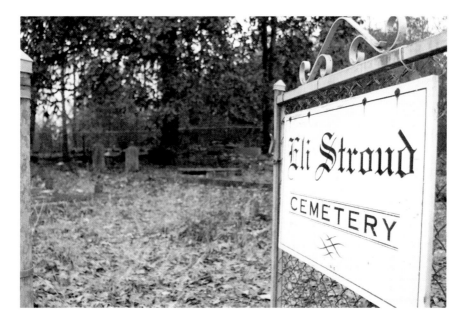

The Eli Stroud family cemetery in Salem, Alabama.

Many locals seem to think that old Eli is still out hunting Indians or tracking wild game in the forest surrounding the old Stroud family cemetery. It is well known that people who live closest to the cemetery don't like to go outside at night for fear of being attacked by Eli's hound or perhaps shot at by the ghostly hunter himself. Mysteriously, animal bones are found regularly in the cemetery. Local folks insist that the bones are from the carcasses of the deer and hogs that Eli hunts and that his hound drags the bones into the cemetery in the late hours of night. Countless wild tales have been spun about the notorious Eli Stroud Cemetery for years, save one. The following is a personal experience that has only ever been shared between friends, until now.

On a calm, cool night in November 1992, two friends were driving home from a high school football game in Smiths Station, Alabama. Being that it was a long way home, the friends decided to take the shortcut through Smiths to Salem by the old Stroud Crossroads. The music blared loudly as the girls drove down the dark and curving country road. The two girls laughed and joked and didn't pay much attention to the open road ahead of them. Suddenly, just inside the curve, a large deer jumped in front the car, and the driver slammed on her brakes to avoid hitting the animal.

The driver managed to stop the car within inches of the deer. Somewhat scared and a little upset, the two teenage girls let out a sigh of relief and then agreed to step out of the car for a second to make sure there was no damage to the car. The driver exited the car first, and the passenger followed. The girls walked around to the front of the car to survey the damage and were happy to see there was none. The deer had gotten away safely.

The passenger made the remark to the driver that she had heard that the road they were on was supposed to be haunted by a man who used to be a great deer hunter. The driver responded by saying, "Well, he's obviously not that great, or he would have got that one." The two girls snickered at the remark and got into the car to sort out their rattled nerves and proceed home. When the passenger started for the handle of the car door, she noticed an icy chill. She tried to shake off the chill, when suddenly she noticed the air temperature drop even more dramatically. It got so cold so fast that her teeth began to chatter.

The driver looked up from her door and said, "Erica, are you OK?"

"Look at my breath, Danielle!" Erica responded. "It's so cold you can see it!"

"It's that ghost hunter!" Danielle joked. "He's coming to get you!"

"Oh shut up and get in the car!"

The two got back into the car and started to drive off when the car started to spit and sputter. "Are we out of gas?" Erica asked.

"No, the gauge says it's full," answered Danielle.

The two girls managed to start the car, and it chugged its way up the hill, where it completely cut off once again. This time, the girls had to get out and push the disabled vehicle up the rest of the hill and off the road.

The two girls didn't realize that they had pushed the car onto the shoulder just outside the Eli Stroud cemetery. Confused and frustrated, the girls debated for the next several minutes about what to do. There was nobody they knew around the area for at least a few miles, and neither of them would dare walk into the house of someone they didn't know to ask for help. Cellphones were not an everyday item during this time either. So walking, as dangerous as it was on an open country road, seemed like the only option left.

The girls gathered together their wits and a few personal items from the car and started off. They hadn't gotten far when a male voice rose up from behind them: "You gals need a little help?" Startled and scared, the pair turned to see a man standing inside the cemetery gate. He was tall, with a small straw hat and brown pants with suspenders over a dingy white shirt.

He looked a bit out of sorts, and neither of the girls wanted to acknowledge that he was even there. The girls stood in disbelief for a few seconds. Erica thought to herself, "Why in the world would some old guy be hanging out in that ragged old cemetery this late at night? He has to be crazy!" Danielle finally responded, "No, we're OK."

Erica whispered to Danielle, "There's no one around here for miles. We could at least let him look at the car."

"Are you crazy!" Danielle cried, "He may be some kind of lunatic!"

In a panicked state, the girls whispered back and forth, trying to decide what to do, when the man spoke again. "Young lady, I will have you know that I am a highly decorated military man and upstanding citizen. You have no reason to be afraid of me!" The tone in his voice had changed. He seemed a bit disturbed by the girls' inability to comply with his offer to help. Finally, Erica convinced Danielle to at least acknowledge the man. Erica walked toward the fence, just out of reach of the man, and said, "Hi, I'm sorry, we don't mean to be rude, but we're a little scared. You see, we almost hit a deer just a little while ago, and now our car won't start. Can you tell us where we might be able to find a telephone to call our parents?"

The old man replied, "A telephone? No, I'm afraid I don't have a telephone."

Erica then asked the old man, "Do you by chance know anything about cars?"

He responded, "No ma'am, I'm sorry. I don't know anything about cars."

Erica was a bit put off at this point since the old man had insisted on helping but didn't seem to be much help at all. Danielle shouted, "Come on, Erica, let's just go!"

Erica looked back at her friend and then turned to the old man and said, "Well, thank you for stopping to help us."

He smiled politely and tilted his hat, then reached down and patted the dog at his side, which Erica had not noticed until that point. The man said, "You're welcome, ma'am."

The two girls proceeded to walk down the highway until finally, hours later, they reached Erica's house. The girls explained to Erica's parents what had happened to the car and about the old man in the cemetery. They phoned Danielle's mom, and Danielle spent the night and agreed to go with Erica's parents in the morning to recover the car.

The next morning, on the way to get Danielle's car, Erica's parents explained to them how dangerous it was to walk on the road at night. The girls expressed their concerns about the old man and the dog they had seen

in the cemetery the night before. Erica's father explained to them that there was an old ghost story about a man who was buried in the cemetery whose family had been killed by Indians. He said that the man's name was Eli Stroud and that he was a great hunter. Erica was familiar with the story but didn't think much of her father's ghost tales; that is, until she made a conscious effort to tie the previous night's events to the legend of Eli Stroud. Danielle and Erica looked at each other wide eyed while replaying the events from the night before in their heads.

To this day, neither Erica nor Danielle has forgotten that chilly November night. This is the first document ever written about the occurrence. It leaves one to wonder if maybe the old man in the cemetery was Eli. Did Eli Stroud reach out from the grave to help those girls? Erica and Danielle like to think that it was the ghost of old Eli Stroud that stopped to help them that night. Erica believes that Eli stopped to help them because no one had stopped to help him in his time of need—or maybe he just enjoyed the conversation. Either way, his ghostly presence can still be felt and seen out at the old Stroud cemetery.

When passing through the Stroud Crossroads late at night, be sure to glance over at the old ragged cemetery with the looming magnolia tree and iron gate. You just may see the little ghost girl, or perhaps the spectral hound or maybe, if you're lucky, Old Eli himself.

THE ALTAR IN THE WOODS

Just outside the city of Opelika is rural Salem, Alabama. The little town of Salem is just like any ordinary southern town with a small square and a few historic homes. Its splendid southern charm is as sweet as the smell of Confederate jasmine that blooms in the spring and covers the tiny dirt road known as Ghost Town Road. The road is not paved, and the red clay beckons to curious travelers. It stretches a few miles into the Alabama wilderness, next to the railroad tracks that lead from Opelika, Alabama, to Columbus, Georgia. Most of the property belongs to the Mead Paper Company, so the area is covered in tall pines with a few pulpwood trails. Hunters lease the property during game season, and many bikers and hikers from all around travel to the area to ride along the scenic routes and dirt roads.

Most folks tend to think it's harmless to take an enchanted bike ride or hike through southeast Alabama's backwoods; however, not long ago it was advised that people stay away from Ghost Town Road, and for good reason. Ghost Town Road was the center of some very disturbing satanic rituals. It started harmlessly enough when people who would recreate in the area started to notice lots of bones lying about the area on the road and in the woods on hiking trails. They were simply dismissed as animal bones, since hunters use the area.

It was later determined that some of the scattered bones found in Ghost Town were actually human and had been dug up from a local cemetery by supposed devil worshippers for satanic rituals. The bones were sent to an anthropologist in north Alabama, where it was determined that they were

that of a male who had been deceased for more the one hundred years. This sparked a bit of interest among local law enforcement and also concerned the tiny community of Salem.

Over the next few years, stranger and more sinister things started to happen around Ghost Town Road. The body of a decapitated man was found just off Ghost Town Road, stuffed into a barrel, and another body of a young female was rumored to have been found, though this was never confirmed. The victims were both believed to have been murdered at the hands of the same Satanist who allegedly dug up the skeletal remains. The Sheriff's Department was now aware that there was a serious issue at hand and began to patrol the area regularly day and night.

Allegedly, a deputy who was patrolling the Ghost Town Road on June 6, 2006, came across a vehicle with several young occupants and pulled them over for suspicious behavior and possible drug and/or alcohol use. The deputy approached the male driver and two other male occupants in the backseat, asking them to step out of the vehicle. A fourth occupant, a young female, was directed to exit the backseat as well. The deputy secured the location by notifying dispatch and called for a second deputy to assist him in the search of the vehicle.

Upon the arrival of the second deputy, the two officers searched the car and found no drugs or alcohol, but they did find some items of interest in the trunk, including ropes, a shovel, tape and what appeared to be a ritualistic dagger stained with blood. The male occupants were then questioned about the purpose of the items found in the trunk and why they had been parked without their lights on. They answered that the items found in the trunk were for work and stated that they were all in construction. When asked about the dagger, the driver just smiled and said, "It's my hunting knife." The deputies then turned their attention to the young female. She stated that she had no idea who the male occupants were and that they had picked her up from a friend's house to "go party."

The naïve attitude of the teenage girl concerned the deputies, and they proceeded to place her in their custody. They eventually let the three male occupants go since there were no grounds to detain or arrest them. The deputies explained to the girl the recent happenings and murders that had taken place over the last few years on Ghost Town Road. They took her to the Sheriff's Department, where she contacted her parents to pick her up.

It was believed that those involved in this particular situation were responsible for the satanic rituals and murders that had been taking place in Ghost Town. Allegedly, when investigators were searching the woods near

The stone altar in the woods near Ghost Town Road in Salem, Alabama.

Ghost Town for clues about the decapitated man in the barrel, they found a large stone covered in blood where the decapitation had taken place. This stony place is now known as the "Altar in the Woods."

No formal charges were ever filed against the suspected men, but locals believe that the young female occupant in the car with those men that night was to be their next victim. The date of the night in question was June 6, 2006 (6-6-06), and though the items that were found in the car were purely circumstantial, they fit a potential murder by sacrificial Satanists. Years have passed without incident, and no more bodies or scattered bones have been reported on Ghost Town Road, but local residents and those folks familiar with the story dare not venture too far down Ghost Town Road or near the Altar in the Woods.

Negative forces seem to have taken over the area and turned what was once a beautiful wooded location into a virtual dump, where garbage is illegally tossed onto the roadside. Those brave enough to go to the altar don't linger after dark. Strange balls of light shoot from the stony area and chase off curious folks. Horrible shrieks of what some say are banshees are heard, and tall, black-hooded figures have been known to stop passing motorists;

they have even approached vehicles and climbed into cars. The creatures are known for scaring the daylights out of even the strongest-willed people. Deputies still patrol the area heavily and depend on the community to call in any suspicious people or behavior.

However, some people still venture out to the Altar in the Woods down Ghost Town Road. The problem with that is that they don't always come back.

THE GHOST OF TANDY KEY

It seems like just about every rural county and big city has its own ghost stories. Most tend to run along the same story lines of "cry baby hollows," ghostly antebellum women, gentlemen soldiers, spooky native folklore—the list goes on and on. Some of the smaller towns and communities tend to share some of the most interesting ghost stories. Perhaps you've heard of Salem, located in Lee County, Alabama. Most folks have never heard of the small town, even though its population today is a little over six thousand, with one very popular ghost resident.

In Salem's infancy, the community was a frontier town, with white settlers living alongside their native neighbors. Salem's roots run deep in the Methodist and Baptist churches, but it wasn't uncommon in the early years for homemade whiskey or moonshine to be a part of an everyday household. With Alabama seceded from the Union, there was no law or order that dictated the sale and distribution of alcohol. Moonshine was used for trading; it was bought and sold within the community, and even from county to county, before a large movement in prohibition started to take place in the late 1840s, spreading quickly from Northern to Southern states, where many people made a decent living from the sale and distribution of moonshine.

Moonshine was kept in most households as a "cure all." Lots of people used it to combat illness. An article from the *Columbus Ledger* in December 1982 mentions a Salem local who recalls the late Dr. McLain of Salem and his use of "white lightning" in the 1918 flu epidemic. It was given in

small amounts to children for cough. Elderly folks in fragile states drank it twice daily, and of course, as with any product that can be abused, moonshine was.

In the earliest days of Salem, many white settlers who made and sold moonshine found that they had very good customers in the native tribes. Native Americans had no prior knowledge of alcohol, or "fire water," as they called it. Many Indians bought and traded whiskey, and it wasn't long before alcoholism was a real problem among the native tribes and white settlers. Salem's town officials tried to control alcoholism through worship and prayer, but without the proper authorities to control problems with alcohol, it soon took its toll on some of the community.

If you ask anyone in Salem, "What's haunted here in Salem?" they will tell you that the old Methodist Cemetery is known for the ghost of a drunken gambler named Tandy Key. Tandy Key's ghost is even depicted in a mural painted on the side of the Salem Antiques Mall located at the crossroads in Salem, painted in the late 1980s. The mural takes you back to a time when Salem was a farming community, with cotton wagons headed to the mill and fur hides hanging on the sides of barns. It shows the old train depot that

Tandy Key as he is depicted in a mural by Ans Steenmeijer. The mural is painted on the back of the Salem Antiques Mall in Salem, Alabama.

once stood near the center of town, the old Shotwell Covered Bridge located just south of Salem and, of course, the ghost of Tandy Key.

The ghost of Tandy Key has been around old Salem since at least 1853. The story of Tandy Key is one of Salem's oldest ghost stories and one that most locals are still familiar with today. Tandy Key was born in Georgia but married and moved to Salem, Alabama. Tandy was an avid gambler, and he loved to play cards. He frequented the town card houses and small-time saloons in the early days of Salem. Tandy was a "slave to the little brown jug," and his grueling nightlife of cards, hostesses and whiskey wouldn't take long to cut his young life short.

In 1853, at just twenty-four years of age, Tandy Key died. The actual cause of death is not known, but rumor has it that poor Tandy drank himself to death. It has also been speculated that he may have been murdered after an argument erupted over a poker game. He left behind a widow and no children. His story, however, has been passed down for generations in Salem.

Even in death, Tandy wouldn't let go of his favorite card games. He advised friends and family that upon his death, a card table should be erected over his grave so that even in the afterlife he could continue the eternal card games he loved so much. As requested by Tandy, a card table marks his grave in the Salem Methodist Cemetery. It's known to the townspeople that on the warmest nights of the year, you can drive past the old cemetery and see strange misty figures around the grave of Tandy Key. Those brave enough to walk outside the cemetery at night have reported the sounds of cards shuffling, clanking glass bottles and ragtime piano music. The smells of strong alcohol—and sometimes even vomit—have been reported, along with cigarette and cigar smoke. Whoops of drunken laughter have also been heard bellowing out of the cemetery in the late hours of the night.

Now for those who have been fortunate enough to venture inside the cemetery, there is a spookier tale to tell. For years, folks wandered the cemetery during the day and night in the hopes that they might get a glimpse of the elusive ghost of Tandy Key. Paranormal investigators have taken photos, audio recordings and videos during casual strolls through the cemetery. One warm evening in August 2010, several members of a paranormal investigation team went to the old cemetery to try to document some sort of evidence of the haunting at the old cemetery. In doing so, an EVP session was held at the six-legged card table grave of Tandy Key.

The card table grave of Tandy Key.

During the EVP session, several questions were asked, like "Mr. Key, are you here?" "What is your favorite card game?" and "May we join you in a game of cards?" The investigators were not optimistic that they had captured anything substantial, but when reviewing the evidence the following day, they made an amazing discovery. A digital recording produced an EVP that was a direct response to a question asked by one of the investigators. She asked, "What is your favorite card game?" Then, a whispering but very clear voice came over the recorder and said, "Hearts." It was a man's voice. Was this the raspy, smoky voice of Tandy Key? After all, they were at his grave site, where more than one hundred reports from generations of Salem's town folks pointed to the ghostly gambler. Had Tandy's spirit come out on this warm summer evening to play a game of hearts?

Since his death more than 157 years ago, Tandy has been at his grave playing cards. An inscription on his grave once read:

Remember man as you pass by,
As you are now, so once was I.
As I am now, so you will be.
Prepare for death and follow me.

The grave that is just next to Tandy Key's marker, belonging to his wife, reads:

To follow you I'm not content
Until I know which way you went.

These inscriptions are a somewhat grim reminder that even in death those we love may not find their way back to us. To some people, this may seem a bit sad that a love for something like strong drink or a card game could spill over into the afterlife, but for others, it's the simple pleasures of life that keep us connected to the memories of our loved ones and perhaps even their ghosts.

THE BREWINGTON HOUSE

The Brewington House is located in Salem, Alabama, and is the second-oldest house in Lee County. The property shares another historical building, the old extension of the Russell County Courthouse. The Brewington House was built by William James Brewington in 1836, and like most homes built at that time, it is large and spacious, with wide hallways and rooms with very tall ceilings. The front porch wraps the entire distance of the front of the house and along the side of the house as well. The walls and foundation are made up of a simple mortar-and-stone mixture that has withstood time for more than 150 years.

Its neighbor, the old Russell County Courthouse, shares a bit of the same architecture. It's a simple two-story structure made of plaster and rock. The bottom level of the old courthouse has two rooms, connected by a single doorway. Both rooms have a small fireplace on either side of the back of the building. Smaller enclosed rooms on either side of the building were added on, possibly for the overflow of prisoners. The upper level can be accessed by the narrow stone and wooden steps. The upper level has one large room and another much smaller room, both with small fireplaces joined by the lower-level chimneys. One interesting feature of the upper level is the large windows that open by double shutters. Upon opening the shutters, one could venture out onto the old balcony.

In the days of the working courthouse, prisoners were held upstairs in small cells, and court was held downstairs. A story was told by a local Confederate soldier from Salem, Richard F. Floyd, that he was present for

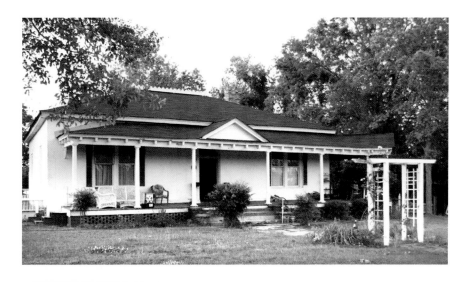

Above: The Brewington House in Salem, Alabama.

Left: The upstairs view from the old extension of the Russell County Courthouse.

court one morning in the early years of Salem. He was eating peanuts and popping them open rather obnoxiously. The justice of the peace, Henry Crowder, gave an order at that time for the sheriff to "arrest" whoever was popping peanuts. Mr. Floyd stated, "I did not say one word, and you can be sure I did not pop another peanut."

The old courthouse has some strange things that take up residence there now. Recently, a strange shadowy figure was photographed in one of the upstairs rooms. The current owner, Mrs. Woodall, used the building for storage for many years and, upon cleaning it out, found an old bed frame that belonged to the previous owner. Mrs. Woodall spent a great deal of time and money having the bed frame restored to its original state. She was so impressed with the finished product that she took it home and set it up in her own room.

Upon sleeping in the bed that night, she was awakened by the light rustle of curtains. When she rose out of her sleepy state, she saw two figures in her bedroom window, that of a man wearing a top hat and a woman with her hair in a bun on top of her head. Mrs. Woodall made no attempts to make contact with the two figures since she was not fully aware of what was taking place. After several minutes, the figures vanished, and the next day, Mrs. Woodall took down the old bed and placed it back in storage.

The Salem extension of the old Russell County Courthouse.

Over the years, there have been other sightings inside the Brewington House. The owner was never a believer in "ghosts" until she moved into the old house. For many years, she owned a large Great Dane, which developed some odd fears after spending some time inside the home. The dog seemed to bark at nothing and was terrified of some rooms of the house. He would frequently bump into walls, and at one point, Mrs. Woodall and her husband witnessed a door open on its own to allow the dog outside.

Mrs. Woodall isn't the least bit bothered by the paranormal activity in the home. Upon purchase of the home, she was informed of its ghostly inhabitants. The elderly lady she bought the house from told Mrs. Woodall that when she sold her the home, she'd be getting more than just a house; she would be getting the house and her husband, too. However, the previous owner's husband had been dead for more than twenty-five years.

In February 2009, a series of tornados ripped through Salem and damaged much of the Brewington Home. However, Mrs. Woodall placed much care and devotion into repairing the old home and restoring it to its original state. Today, it stands as a living legacy of the history of Salem, Alabama.

The Little Girl in the Window

The sleepy little town of Salem, Alabama, can best be described as "the town that time forgot." Its dirt roads whisper with the sounds of covered wagons and the bumble of cotton bales being loaded to take to the mill. Its country charm is reminiscent of early southern America. Memories live in Salem, the kind of memories that stay with a person for a lifetime.

In the early part of the year 1835, frontier people came in covered wagons to settle Salem, and within just a few years, the area was a small community complete with churches, church campgrounds, a school, a general store, a hotel and several fine homes. One of these fine homes was that of a doctor named Daniel Floyd and his family. Daniel Floyd was born in Ireland and immigrated to Virginia. He settled in Salem in the fall of 1836, shortly after the original settlers had arrived.

Dr. Floyd quickly took up residence in Salem as the town's first doctor. His education and background made him a valuable asset to the community, since having a working doctor within such a small frontier community was not too common during that time. Dr. Floyd's home was situated just off the Salem Crossroads, with his office located in the front yard. Dr. Floyd, his wife and their nine children lived in the cozy home in Salem until their deaths. The home has been passed down through generations of Floyd descendants over a period of about 170 years until the current resident bought it from the last owner and descendant of Dr. Floyd.

The home is an interesting structure, and paranormal investigators Faith Serafin and Karen Davis have had the privilege of touring it

personally. The rooms are large, with beautiful hardwood floors still in good condition. The high ceilings are made of wooden planks, and the rooms are connected by doors without a single hallway. Many additions have been made over the years, but in general, the original floor plan and foundation have stayed the same. Mrs. C.K. Dunn gave a description of the home in the quote she submitted to the book *Alabama and Her Forbears*, published in 1983:

> *It had four rooms, two large rooms in the front of the house and two long narrow rooms in the rear of the building. One unusual feature was no hallway. The kitchen was out behind the main house and not connected to it.*

The Floyd home has seen a lot of history and has a few interesting features and mysterious marks. Besides its odd structure, two *X*'s mark each pillar outside the front door. The *X*'s have been on the columns since before the current owners purchased the home. When asked about the mysterious *X*'s, the current owners said that they were not aware of the origin or meaning of the *X*'s, and during renovations, they decided not to cover up the strange marks. There are a couple of theories that may explain the *X*'s. One theory is that because Dr. Floyd was a doctor during the Civil War, his home may have been used as a hospital during the latter part of the war. Many Union soldiers marked houses with *X*'s so they would not be destroyed.

The second theory is that the home may have been marked after a fire consumed much of Salem. Evidence in the attic walls and floor suggests that at some point the Floyd home suffered a fire. There is a report of the fire of 1854 in the *Columbus Ledger Enquirer*. Estimates ranged in the thousands of dollars in damages all over Salem. Many people lost their homes, businesses, barns and more. Dr. Floyd's home may have been marked with an *X* to indicate that it had suffered damage.

Whether the *X*'s were made postfire or by soldiers, one can only speculate, but one thing is for certain about the old Floyd house. It definitely has its fair share of ghostly residents. Recently, the current residents experienced ghostly apparitions and strange phenomena in the home. As a longtime resident of the Salem community, Faith Serafin has had her own run-in with the ghost of the Floyd House.

When Faith was very young, she traveled the quiet and sleepy back roads of old Salem, often with her grandparents. Passing the Floyd House was not a part of the trip she enjoyed since she would constantly see a little girl

The Floyd House in Salem, Alabama.

peering out of the attic window. Faith would ask her grandparents, "Why is that little girl always in the attic window?"

Her grandparents humored her a lot and would say things like "She must really want to be your friend" or "Maybe she is looking for something." Faith noticed a very odd significance about the little girl. She was always dressed in the same tea-stained dress with a dark-colored overall jumper on top. Her hair was long, dark blond and always parted in the middle. As Faith grew older, the little girl in the window never aged. Over time, the phenomenon seemed to get less and less frequent. She would drive past the Floyd House every day on her way to work and back. After a long period of time, Faith stopped seeing her all together.

In February 2009, a devastating tornado hit Salem, and some of Salem's most historical treasurers were lost. Dr. McLain's office was leveled, and the barn next door to the Floyd home was destroyed as well. The old Brewington home suffered significant damage but was salvaged. The Brewington home shares the same property as the Old Russell County Courthouse extension, which sustained minimal damage. The old Floyd home was severely damaged as well. One entire side of the attic had been ripped off by the tornado. Large trees that had smashed through the roof

during the storm lay in the attic, and some of the bottom-floor windows had been blown out.

Once Mother Nature had unleashed her fury on Salem, many local people ventured out to survey the damage done by the storm. Most of the roads were blocked off to oncoming traffic since power lines were down, and some of Salem's oldest druid oaks hung by nothing more than a ribbon of wood across the roads. Determined to do her part for her community, Faith set out for Salem's historical district to survey the damage and to check on friends who lived there. Faith did not take into consideration that she would be walking past the one house in Salem whose ghost had haunted her for so many years. She made her way into the main part of town, where she could see the results of elemental forces. It was heartbreaking. There was so much loss, but Faith was appreciative at the same time to see that Salem had suffered no causalities.

Overcome with emotion, Faith sat down on the old wooden steps that once served as the entryway to Dr. McLain's office. Salem had never seen a storm like this and hopefully never will again. She took a few pictures of the downed trees and what was left of old Doc McLain's. Alabama Power workers were lifted high in buckets on trucks, trying to restore power to electrical lines. The Lee County deputies were directing traffic around the damaged areas, and the Red Cross workers diligently went from residence to residence checking on the inhabitants. Faith was able to regain her emotions and take a few photos; then she made up her mind to go home. As she turned to walk back to her car, she once again made her way past the old Floyd House.

In an instant, Faith felt the urge to stop, and for that second, it was as if she had stepped back in time. In the middle of all that loss, chaos and fear, there was laughter—the laughter of children. It was a welcoming sound. Faith smiled in between her tears and looked up to see several children laughing and playing in the yard of the old Floyd House. They ran around and around the house. A small boy splashed in the puddles, and a little girl and two other boys followed. It was as if not a bit of that storm had distracted those children. They seemed to run and play in unison. The house was battered but not broken. Seeing those children play so happily was very comforting in the midst of such awful devastation. Faith snapped a single photo of the home from the side with the most damage and made her way home.

Several months later, Faith started to organize information about the history of old Salem. She approached the owners of the Floyd House

with information about its history. The owners were more than welcoming and were eager to hear about the history of their home. During this conversation, the lady of the house reluctantly informed Faith of the strange things that happen in the home. Faith had informed her that as a child she had seen a little girl in the attic window. Once Faith relayed that particular story, it was as if they had some sort of connection. The woman proceeded to tell her that she felt very strongly that there were indeed ghosts in the home. The owners reported that the sounds of footsteps in the home were very frequent. Also, a photograph of what appeared to be a man in the attic window on the side of the house was captured by the owner. When Faith asked the owners about the photo, they informed her that it was taken just after the storm when they were taking photos for their insurance company.

During that conversation, the emotion Faith had felt after the storm came flooding back to her. She thought about how sad she had felt when she saw all the damage from the tornado and how comforting it was to see the children playing in the yard of this very house. Faith expressed to the owners that the repairs done to the home since the storm were a big improvement and how lucky they all were to have survived such a potentially disastrous situation. They ended their conversation with an open invitation for house calls and exchanged e-mails and phone numbers.

A few weeks later, the owners contacted Faith with some information regarding Salem 's history that was given to them by their pastor. It was information that had been kept in the Baptist church records since its establishment in the mid-1800s. Faith was excited to see what new information might surface and eagerly went over to the Floyd home. While she was there, she was treated with the same warm hospitality she had come to expect from the family, but this time, a strange reality would come to light that haunts her to this day.

Faith had met the children on several occasions and had the impression that she had met all of them. While she was talking with the owner about the contents of the CD given to her by their church pastor, a young woman walked into the room. Faith looked a bit puzzled, since she had not met the girl before. The owner explained to Faith that the young woman was her only daughter. Faith was a bit surprised. She explained to the owner that she didn't look old enough to have a daughter that age, since the young woman was obviously in her late teenage years. The lady of the house smiled politely with a slight blush and replied with a modest "Thank you." Faith stood quietly, listening to the owner tell her what was on the CD. She made

no effort to ask her the question that was burning in her head. If the young woman in the room was the homeowner's only daughter, then who was the small female child she had seen outside after the storm running through puddles with the boys?

They finished their conversation, and Faith set off for home, the whole time thinking to herself how confused she was. She knew the little girl she saw in the yard with the boys just after the storm was not the young woman she had met that day. Who was the little girl she had seen in the yard after the storm? Faith was halfway to her house when she realized that the child she had seen after the storm was the same little girl from the window all those years ago. Faith was so shaken that she had to pull off the road to gather herself before she could continue home.

All the years of seeing that little girl peer out at her from that attic window, only to disappear from her sight and then her memory, and now she had resurfaced. But who was she? Where did she come from? Why did she stay in the old Floyd home? These are questions we may never know the answers to. Faith thinks the girl may have felt lonely all those years when she saw her looking out the window, longing for a friend to play with or companion to talk to. Now that the current residents are there with a warm and loving family, children and pets, she feels at home and perhaps safe and happy. Maybe she waited all these years for the right family to come into her home so that she could spend her afterlife in happiness.

THE DEVIL'S MOUTH
AT MOFFITT'S MILL

Much Native American lore exists within Lee County. Stories of Indian maidens, brave warriors and tribal battles between the divided Creek tribes are centuries old. Most of these stories have been spread verbally over hundreds of years and are some of America's oldest history. The Creek tribes that lived in the Lee County area were a nonhostile group of hunters, gatherers and farmers. Most lived in harmony with their neighboring tribes, but the tribes north of Lee County did not. Upon the arrival of European settlers from the northern United States, the natives were eventually pushed out and removed from their lands.

Cow Creek tribes were native to the area for thousands of years and lived off the land, rivers, lakes and streams that made up Lee County. Within these rivers and lakes were an abundance of fish, birds and other wildlife that would survive on the same terrain as the natives did, and there is one Creek legend of a great serpent that is still alive today.

Near the banks of the Chattahoochee River lived many Upper Creek tribes. The legend of the Tie Snake was born from these tribes. This legendary snake was said to be as long as half the river from side to side, and its large humps could be seen protruding from the water like floating barrels. Its massive head could swallow large fish entirely, and legend says that it was frequently seen with deer wrapped in its tight coils, constricting life from its prey and then consuming it on the banks of the Uchee River.

This beast was rumored to have been driven out of the rivers and streams by the white man's smoking canoes. Creek elders told early historians that the Tie Snake was the avenger of the red people and that so long as the white settlers continued to destroy villages and take away Indian lands, the Tie Snake would forever be lost in the depths of the rivers and streams.

Some small cave systems can be found in and around the Chattahoochee area, including in parts of Lee County, Alabama. A small river system known as the Little Uchee empties into a shallow cave system near Dan Johnson Road in Salem, Alabama. This location is known as Moffitt's Mill for the old gristmill that once stood there. Moffitt's Mill has long been a place of enchantment for many people. Its scenic waterfall and cool, shallow pools make it a haven for swimmers on hot and humid summer days. When temperatures soar above one hundred degrees, you can find many people here. Some people travel for miles just to see the magnificent beauty of the natural waterfalls and abundance of river life.

If you're one of those people who thinks you might want to see this breathtakingly beautiful location, you might want to think again. There have been several deaths here over the years, and several people swimming here have nearly drowned. In the early 1970s, a young female was reported to have drowned at Moffitt's Mill, and her body was never recovered. In the mid-1990s, a teenage boy from Lee County was swimming with friends one weekend at Moffitt's Mill. He jumped off the stony cliffs from several feet in the air and once he hit the water, he didn't come back up. When the rescuers arrived on the scene, they found that the young man had been sucked into an underground hole located just behind the falls. The pressure from the suction was so great, said one rescuer, that he nearly drowned trying to recover the young man's body. The boy was later pronounced dead. In another instance, a family was swimming with small children, and their six-year-old son was yanked from his father by the force of the suction. The boy nearly drowned, along with his father in the attempt to free him.

Attempts have been made by the county to keep people from going to Moffitt's Mill, but they have made little impact on the safety issue. While researching the area, information surfaced that mentioned the area of the Little Uchee as a prime location for the Tie Snake. In fact, it's said that the caves and holes that have sucked down many unsuspecting swimmers at Moffitt's Mill have also caused the demise of many Creek Indians. Those who would not heed the warning to steer clear of the Tie

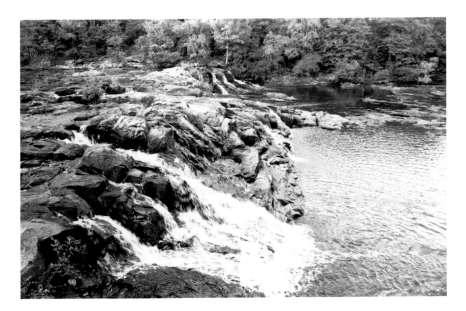

Moffitt's Mill in Salem, Alabama.

Snake's domains would surely be dragged down to its underground lair or crushed in its mighty coils. Some bodies of these missing Indians were found, but others were not.

This tale may not sound like more than the legend of a great snake made up to scare people away from a potentially deadly location, but it's definitely not without cause for concern. While most people will tell you they have never seen more than an occasional water moccasin at Moffitt's Mill, others have seen something a bit more disturbing. If you're planning a trip to Moffitt's Mill, you'd better think twice. The ghosts of many Indian spirits can be found here, along with haunting visions of others who have perished in these subterranean caves.

Strange as it may sound, it is during the winter months that most of the reports of apparitions from Moffitt's Mill tend to come out. Occasionally, locals go to photograph the raging Uchee River after a storm or catch the occasional snowfall on video. The sheer beauty of the place makes it hard to resist, but sometimes that beauty can turn into an awful scene of panicked and half-naked natives frozen in the shallow pools of water. They aren't able to break free from the force that keeps them there, destined to forever be submerged in the "Devil's Mouth," as some call it.

The legend of the Tie Snake died out many years ago, but the metaphor in reference to the Devil's Mouth at Moffitt's Mill has resurrected the avenger of the Creek Indians. If the crushing serpent of the Devil's Mouth continues to claim victims, then the warnings should be heeded by the passerby who might venture too close to his domain. Or you may find yourself lost in the Devil's Mouth for eternity.

THE HEADLESS GHOST OF HIGHWAY 80

On the edge of the Lee/Russell County line, there is a sinister story of a murder and accidental death that is as true as it is chilling. In the 1930s, a married couple lived on a dirt road just off Highway 80. The man was sadistic and abusive to his wife. It was the Great Depression, and many people were destitute, hungry and desperate. The man and woman were lucky enough to have a small patch of crops and often would have plenty of food to make it through the season. Desperate to make a little bit of money, the woman decided to sell a basket of corn to a neighbor man for a small profit when her husband went to town, knowing he would not miss the corn. Little did the woman know that the man had forgotten something and was coming back to their house.

The man saw his wife speaking to the neighbor and flew into a fit of rage. He waited for the neighbor to leave. Once he did, he grabbed the axe and began to beat his wife with the blunt end. The neighbors could hear her screams from up to two miles away. In one large swing of the sharp end, the man nearly chopped his wife's head clean off. He ran into the street wielding the axe and covered in his wife's blood. He was going to run to the neighbor's house. What he didn't know was that the neighbor was racing back to the house because he had heard the woman's screams. As he ran toward the neighbor's Ford V-8 pickup, he was run over and decapitated.

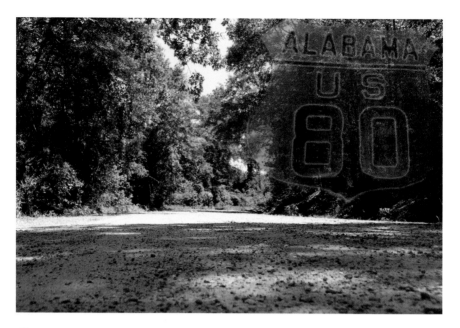

"Ever since, the woman's screams can be heard, and a headless man has been reported in the road when the moon is full."

About two days later, a man was on the little dirt road on his horse and buggy. Suddenly, his horse reared up, and as he attempted to calm the animal, he saw a headless man standing in the road. Scared to death, the man ran his horse all the way home. Ever since, the woman's screams can be heard, and a headless man has been reported in the road when the moon is full.

There must be something about this particular road that brings out the spooks because several years later, two teenage boys were racing their hot rods down this little road when, for an unknown reason, one lost control of his car. It went spinning in circles, crashing into the other car and killing both boys instantly. Now it is often reported that the phantom sound of the car crash can be heard on this road. Could it be possible that the headless ghost stepped out onto the road that day? Was the deadly crash the result? No one will ever know.

THE HUGULEY HOMES

In 1963, Al and Velma Huguley purchased property located in Salem, Alabama, just off Highway 169 on what is today County Road 201. The land was purchased from Neil Koon. The Huguley family cleared the property and moved their first house onto the property from Columbus, Georgia, by way of the Davis House Moving Company. It was a frame house with an L-shaped front porch, which Mrs. Huguley was very fond of. The Huguley family had a small farm on the property with chickens, hogs, horses and some cattle. They planted vegetables in the spring and summer. Mrs. Huguley was also enrolled in nursing school, and Mr. Huguley worked for the County Highway Department and helped to build county roads and even the Lee County public fishing lake.

In 1968, the youngest son, Leon Huguley, was nearly sixteen years old and attended the old Chevella High School, known today as Russell County High. One particular weekend night, a young man came by the old Huguley home. The boy's name was Gary Letlow. It wasn't uncommon for Gary to come around the Huguley place, since he was the same age as Leon and they had all but grown up together. Gary typically came in on his own and made his way to the bathroom, where he would wash his hands and then go to the kitchen and open the tap for a glass of water. On the night in question, Gary did just that. He also asked Mr. Huguley if Leon could attend a movie with him in town. Mr. Huguley was a bit hesitant to allow Leon to go, since Gary hadn't had his driver's license for long. Gary asked Mr. Huguley to borrow ten dollars and then

hung around for a few more minutes while they said their goodbyes. Then Gary made his way home.

Gary hadn't gotten far from the Huguley home when he lost control of his car and ran off a bridge, dying almost instantly. Some time went by before the car was found with Gary inside. Upon discovery, it was noted that a large metal beam from the bridge had impaled the car through the passenger side, right where Leon would have been had he been with Gary that night. Sometime later, very strange things started to happen at the Huguley residence. Some nights the toilet would flush when no one was in the bathroom, and minutes later, the water in the sink could be seen and heard running in the bathroom. One night, Mr. Huguley woke to the sound of running water. He followed the sound into the bathroom, where he saw the sink filling with water due to the open tap. He turned the water off, and suddenly the toilet began to flush. If that weren't strange enough, once he turned off the water in the bathroom, the kitchen sink mysteriously began to run with water.

This strange phenomenon went on for several weeks, until one night, Mr. Huguley had simply had enough of the ghostly antics. He was lying in his bed listening to the radio when he heard the bathroom sink begin to run. He began to shout at the unseen force. "Gary!" he yelled. "I know it's you, and I know you've come back, but please, Son, please stop turning my water on!" From that point on, there were never any further episodes with the water in the Huguley home.

In 1971, the house burned down due to faulty electrical wiring. There were no casualties. Shortly thereafter, in 1972, a second home was purchased by the Huguleys and moved from Whitten Road in Columbus, Georgia, to the same location as the previous home in Salem. The Huguley family lived there for several more years.

In 1984, the Huguleys bought a third home and had it moved onto their property next to their original home. The third house was originally army barracks built in the 1940s at Fort Benning, Georgia. The airborne barracks on post were being renovated and rebuilt, so several of the old airborne barracks were sold to housing companies for quick sale. The Huguleys purchased the old building for $1,200.

They started renovations on the old barracks building, and once the remodeling was complete, they rented it out. The first family to live there were relatives of Mrs. Huguley and didn't reside in the rental for very long. They reported strange noises at night, and sometimes during the day, the doors would open and close on their own. The second family was

Al Huguley in front of his former home on Lee Road 201 in 1980.

a military family, and the last family to live in the old barracks house was a couple with two young children, who also reported the same strange phenomenon with the doors.

In the late 1980s, Mr. and Mrs. Huguley gave their original home to their eldest son, who lived there with his family. Mr. and Mrs. Huguley then moved into the old barracks house next door. The eldest son divorced and remarried, and in 1997, a second house fire consumed his house, killing his wife. Her ghost has been seen on the property as well. She wears a long white gown and is said to be accompanied by a blinding white light. Her ghost has been seen in the surrounding pasture, wandering the grounds. She drifts high off the ground and has been known to be the protector of small children. A neighbor reported that while watching his three small children one evening while his wife was at work, he witnessed the ghost. He had left a back door open, and his two-year-old son had wandered out into the road outside. Once he noticed his son was missing, he went outside calling for him, and when he rounded the corner of the

house and saw his son in the street, he panicked, fearing his son might get hit by a car before he could reach him.

He started toward the road when a white light began to emanate in front of his son in the street. He said the light was so blinding that he could no longer see his child. Fearing that an anxiety attack was causing him to hallucinate, he struggled forward through the yard toward the gate that let into the driveway. He reached for the gate, and suddenly the light came over him with so much force that it knocked him backward into the yard. For a second, he thought he was having a stroke or seizure, but he collected himself quickly and got back up, only to find his little boy standing in front of him, holding the hand of a fair-haired woman in a long white gown. She placed the hand of the small boy inside his father's and turned away. The neighbor said he watched her walk across the street and onto the property where the old burned house once sat. Then she disappeared. The eldest son soon moved and sold the property.

Mr. and Mrs. Huguley now lived in the newly renovated barracks house and added an addition onto the side, giving it a more modern look. Even though the Huguleys had moved into the house next door, it didn't keep the ghosts at bay. One late night, Mrs. Huguley woke to the smell of something burning. Fearing they had a house fire, she woke her husband, and as they made their way through the house, they found nothing on fire. They inspected the entire house and found no evidence of anything that may have caused the smell. Mrs. Huguley even called an electrician out the next day to inspect the wiring in the home, and the electrical engineer found that everything was up to code and correct.

On another occasion, Mr. Huguley woke in the early evening hours to the sound of whispering and shuffling in the house. Fearing they may have had a burglar in the house, Mr. Huguley grabbed a rifle that he kept near his bed and went to investigate. He could hear the movement of what sounded like shuffling feet and whispers, but he walked the entire house and found nothing. The house was empty and locked; there was no sign of a break-in anywhere, and nothing was taken.

In 2001, the Huguleys moved from the old barracks house and deeded the house and property to their only granddaughter. Sadly, Mr. Huguley passed away in 2005, and now the newest owner reports that the "Huguley haints" are still causing a bit of commotion. The children of the current residents have reported hearing a woman call their names, and blankets are frequently pulled off their beds and onto the floor. A friend visiting from England who had never heard the family ghost stories

was awakened in the middle of the night by the presence of a man, who shook the bed she was sleeping in.

Another friend, on her first visit, asked, "Is your house haunted?" When pressed about why she asked, the friend said, "I just saw a little girl on the back of the couch with a purple sweat suit. I thought it was your little girl until I saw her come running down the hall. When I looked back at the couch, the little girl was gone."

Mr. Serafin, the current owner's husband, was a skeptic when it came to ghosts and all things paranormal until he witnessed firsthand the ghost walk through the house. As he was lying in bed one night watching television, he heard the kitchen door open and footsteps coming toward his bedroom in the back of the house. Expecting that the children had just come in, he waited for a few minutes before he realized it wasn't the children. Mrs. Serafin said, "That's not the kids." He got up out of bed and said, "Yes it is." As he walked through the house, he started to get a bit nervous since the children were nowhere to be found. On another occasion, Mr. Serafin was pulled from his bed by his feet by something he could not see or hear.

The youngest child and Mrs. Serafin were sitting in their living room when they heard the kitchen door open. The reflection from the kitchen in a glass china cabinet showed a man in a dark-colored work uniform come in the kitchen door. He said nothing but made his way toward the back of the house. The child looked up at the sound of keys as they jingled on his belt loop and happily shouted, "Daddy's home!" Mrs. Serafin watched the man walk through the house and assumed it was her husband, who had come in early from work. Several minutes went by, and then she went to see where he went. She looked all over the house and outside but found no one. She then proceeded to phone her husband's work to find out where he was, and to her surprise, he answered the phone. When she told him what had happened and that their little girl had seen the man, too, they were both a bit shaken up.

The smell of cigarettes can be followed from room to room in the barracks house; oddly enough, no one in the home smokes, nor do they allow smoking in the home. Tall, shadowy figures roam from room to room, and smaller dark shadows dart around corners and behind curtains in a playful manor. No one is sure why they are there; they just know that they are. A friend once said, "It's because you take them in like stray cats." With so much that makes up the world we live in, little is known about what makes up the world of the nonliving. If it's not up to us to decide where we go after death, then where *do* we go?

BIBLIOGRAPHY

Cherry, Francis Lafayette. *The History of Opelika and Her Agricultural Tributary Territory*. Opelika AL: Genealogical Society of East Alabama, 1996.

Nunn, Alexander. *Lee County and Her Forebears*. Opelika, AL: Published with cooperation of Probate Judge Hal Smith and Commissioners J.G. Adams, Bobby J. Freeman, J.L. Hearn and Huey P. Long, n.d.

Opelika-Auburn News, October 2008.

Wright, John Peavy. *Glimpses into the Past from My Grandfather's Trunk: The Life of William Wilmot Wright, 1825–1905*. N.p.: Outlook Publishing, 1969.

ONLINE SOURCES

http://digital.archives.alabama.gov
www.ancestry.com
www.auburn.edu
www.history-sites.com
www.lib.utexas.edu
www.preserveala.org

ABOUT THE AUTHORS

FAITH SERAFIN is a longtime resident of Lee County, Alabama, and lives in Salem. She has a vast knowledge of the history in Salem and Opelika and volunteers her time in local schools to help promote historical programs for school-age children and the importance of historical preservation. She has spent many years studying the history of her community and is an avid folklorist and historian. Faith also works as the official tour guide of the Sea Ghosts Tours at Port Columbus National Civil War Naval Museum in Columbus, Georgia, and is director of the Alabama Paranormal Research Team, a nonprofit organization dedicated to the research of paranormal science.

MICHELLE SMITH is a resident of Auburn, Alabama, and a graduate of Auburn University with a BA in criminal justice and a BA in criminology. She works in local law enforcement. Michelle is a dedicated historian and researcher, and she is also a researcher for the Alabama Paranormal Research Team and volunteers her time at the Sea Ghosts Tours at Port Columbus National Civil War Naval Museum in Columbus, Georgia. Michelle writes a series of blogs about historical pieces, particularly in the South, and true crime pieces, as well as haunted sites and their historical significance.

JOHN MARK POE is a professional historian in Opelika and Auburn and also volunteers his time as a reenactor for several festivals and events within the state. John Mark has a bachelor's degree in history and a minor degree

in African American studies. John Mark is an active paranormal researcher and investigator with the Alabama Paranormal Research Team, as well as a volunteer at the Sea Ghosts Tours at Port Columbus National Civil War Naval Museum in Columbus, Georgia.

Visit us at
www.historypress.net

..

This title is also available as an e-book